African Art

❖❖❖

Virginia Museum of Fine Arts

by **RICHARD B. WOODWARD**

Curator of African Art

Virginia Museum of Fine Arts

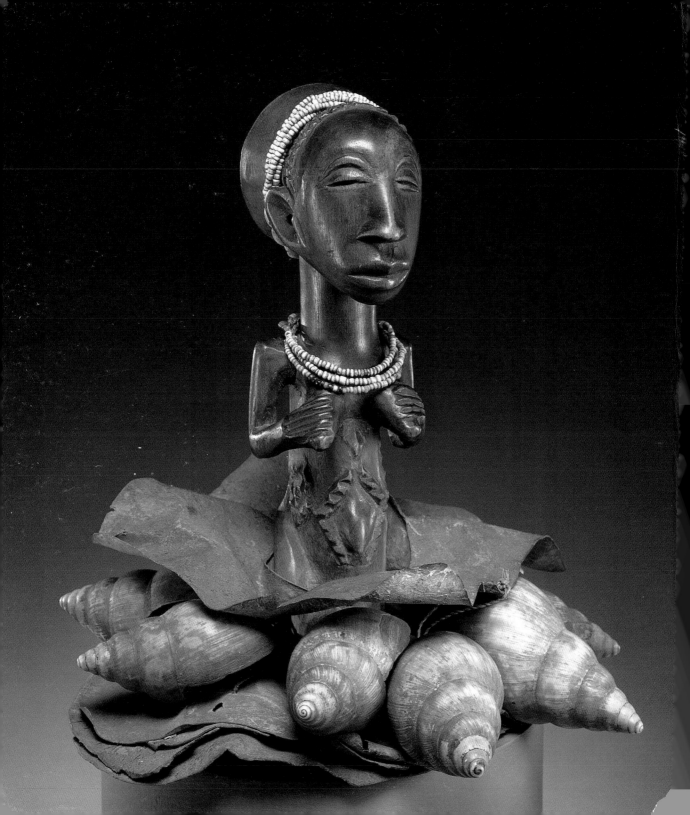

Seeing the Spirit

To see Africa is to look across vast tracts of land and endless ages of time, over sun-baked deserts and into damp tropical forests, along rolling savannahs toward cool highlands and jagged mountain peaks. To see Africa is to look upon a motherland that has cradled life since the dawn of time. This vision comes alive in many vibrant cultural landscapes where people have found ways to express their religious beliefs, social customs, and life's experiences with a spectacular array of stories, music, dance, and art.

No single book and no art collection could hope to show it all — from the earliest development of the human race in East Africa's Rift Valley several million years ago, to today's cities of Dakar, Abidjan, Lagos, Kinshasa, Nairobi, and many more. Between these extremes of time, Africa and her people, like people the world over, have known all that life can bring: feast and famine, wealth and poverty, deepest agony and joyous celebrations of the spirit, migration and settlement, rising and declining civilizations, peace, war, and influences good and ill from other parts of the globe. Africa's history is a vital part of the world's heritage, a history that needs to be better known so that we can be enriched by its lessons, learn more about its people, and appreciate its dazzling artistic creations.

The works of art illustrated in this book represent but a fraction of this great legacy. In date, they are neither Africa's oldest nor its newest, but were made during the past five to six hundred years. In fact, most were made during the past century or two, though they reflect earlier traditions and styles. In place of origin, these objects do not cover the entire continent, but represent the wealth of cultures and influences south of the Sahara Desert. They span the great distances and the diverse cultures that have developed between Africa's western reaches, near the Atlantic Ocean, and its eastern and southernmost lands, along the Indian Ocean.

Most important, these works of art are beacons of the vibrant creativity of the people who made them. They communicate significant cultural and historical information and reveal the intense inner spirit that motivates the people and their cultures.

In general, this art might be characterized as "living art." The sculptures, masks, scepters, crowns, and other objects in this book were not made to be put on motionless display solely for the enjoyment of their artistic forms. Indeed, they were meant for show, but as symbols of authority or moral lessons, being used or worn in special events and settings:

on altars and in shrines, in civil and religious ceremonies, in masquerades and festivals, and sometimes in daily life. These objects are instruments for communicating with spirits, for signifying a person's status in the community, for resolving conflicts, and for passing wisdom and traditions on to succeeding generations. As a result of their use, many of them bear the effects of frequent handling. Some show signs of wear in surfaces polished smooth from touching, areas of damage, and even repairs. Others are coated with offerings that have been poured over them, have had pigments applied to them, or have mysterious bundles, beads, shells, and animal pelts hanging from them. Masks, one of Africa's most dramatic and widespread art forms, are brought out on special occasions from places of safe-keeping to be danced, accompanied by music and song, in spectacles that are the ultimate in "living art."

An object's intended use often contributes to its distinctive appearance, which prompts several questions. Who made it? Why did they make it? Who owned it? How did they use it? What does it represent or mean? Answers to these questions are basic to a clearer understanding of any work of art.

But the special nature of African art suggests two more questions: when was it used, and where was it used? These last two questions are important to understanding African art, because many of the works shown in this book would not be seen or used on a daily basis. Instead, most of them are closely tied to social and religious practices, and would therefore be subject to special conditions and restrictions. Some would only be used on particular occasions, such as celebrations honoring the ancestors, at planting time, harvest, and other festivals during the yearly cycle, for a king's investiture, rites of passage of young men and women, or during a time of crisis in a village. Other objects would be restricted to specific settings: religious altars, secret locations outside a village, or in a king's compound where only members of the royal court would be permitted to go. These are but a few examples of the cultural contexts in Africa where works of art play an important role. Their uses reveal spiritual attitudes shared by people of many different cultures toward the land, the ancestors, and toward important events both in the life of a community and in an individual's life.

The prominent role that art plays in the civil and religious fabric of African cultures has infused many of the sculptures, jewelry, and textiles with a symbolic "language" of signs and forms. These coded messages can be interpreted or "read" by one who has learned the precepts of the society that created them. Such objects also serve as a focus for the instruction of young members of that society, reinforcing their cultural identity, handing down lessons of history, and strengthening commonly shared moral and social values. Because the works of art have such close ties with social and religious institutions, in order to understand them more fully we must know something about the underlying cultural context. Sometimes this background is easy to obtain, but often it is difficult due to restrictions against sharing specialized knowledge with anyone who is not a part of the society itself.

One of the greatest achievements of Africa's artists is their ability to clothe invisible ideas with visible form, to create works of art that embody symbolic and spiritual content. The basic elements of their artistic vocabulary are the human figure, animals, abstract or geometric patterns, natural substances, and man-made materials. In bringing unity to form and concept, these artists often stress

those elements that hold important symbolic meaning, while other parts are minimized. As a result, the intentional distortion or alteration of human and animal forms gives many images a poignant character. A prominent example is accentuation of the head. In human figures, the head is often made larger in proportion to the body because it is considered to be the center of the soul, and therefore the most important part. Sometimes the head is further emphasized by the addition of a magnificent crown or hat, or an elaborate coiffure. The spirited customs of wearing crowns, hats, and head wraps, and the love of elegant and dramatic coiffures further underscores the dynamic relationship between art and life in many African cultures.

Artists also weave forms and ideas together by combining the different elements of their vocabulary—human and animal forms, abstract patterns, natural substances, and man-made materials. In some cultures, for example, the lordly and powerful elephant and the fierce but reclusive leopard are symbols of kingship. Figures or masks that represent a king often incorporate such symbols by depicting the animal or attaching actual elements from that animal, such as a pelt or a tooth. In a similar way, abstract patterns (having symbolic meaning) and natural and man-made substances (having spiritual or curative powers) may be used in an object to indicate social status or ancestral lineage or to convey spiritual messages. For example, a statue or mask might bear a variety of elements and meanings: white clay as a symbol of purity, herbal roots as a sign of healing, cowrie shells to indicate wealth, and metal to signify power.

Like so many layers, these varied signs and symbols make it possible for a single work of art to convey more than one message. The great reward that comes with learning about these objects is to be able to perceive both their visible form and their invisible spirit, to know what they share in common and how they differ, and to see more clearly the diverse texture of Africa's richly creative cultures.

RICHARD B. WOODWARD
Curator of African Art
Virginia Museum of Fine Arts
Richmond

EDITOR'S NOTE: The objects featured in this book come from many different cultures. Because these cultures existed long before present political boundaries were established, each culture lives in a region that includes one or more African nations. For the sake of brevity in an introductory book such as this, the exact locations for those cultures within each country has not been indicated.

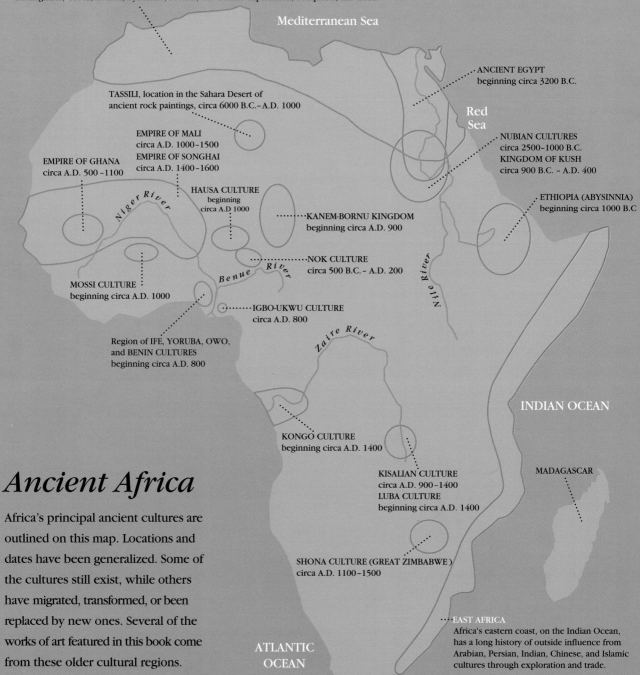

NORTH AFRICAN COAST
Africa's northern coast, on the Mediterranean Sea, has a long history of outside influence from Phoenician, Carthaginian, Greek, Roman, Byzantine, Persian, and Islamic exploration, conquests, and trade.

Mediterranean Sea

ANCIENT EGYPT
beginning circa 3200 B.C.

Red
Sea

TASSILI, location in the Sahara Desert of ancient rock paintings, circa 6000 B.C.–A.D. 1000

NUBIAN CULTURES
circa 2500–1000 B.C.
KINGDOM OF KUSH
circa 900 B.C. – A.D. 400

EMPIRE OF MALI
circa A.D. 1000–1500
EMPIRE OF SONGHAI
circa A.D. 1400–1600

EMPIRE OF GHANA
circa A.D. 500 –1100

ETHIOPIA (ABYSINNIA)
beginning circa 1000 B.C

Niger River

HAUSA CULTURE
beginning
circa A.D 1000

KANEM-BORNU KINGDOM
beginning circa A.D. 900

Benue River

NOK CULTURE
circa 500 B.C. – A.D. 200

MOSSI CULTURE
beginning circa A.D. 1000

Nile River

IGBO-UKWU CULTURE
circa A.D. 800

Zaire River

Region of IFE, YORUBA, OWO, and BENIN CULTURES
beginning circa A.D. 800

INDIAN OCEAN

KONGO CULTURE
beginning circa A.D. 1400

MADAGASCAR

Ancient Africa

Africa's principal ancient cultures are outlined on this map. Locations and dates have been generalized. Some of the cultures still exist, while others have migrated, transformed, or been replaced by new ones. Several of the works of art featured in this book come from these older cultural regions.

KISALIAN CULTURE
circa A.D. 900–1400
LUBA CULTURE
beginning circa A.D. 1400

SHONA CULTURE (GREAT ZIMBABWE)
circa A.D. 1100–1500

ATLANTIC
OCEAN

EAST AFRICA
Africa's eastern coast, on the Indian Ocean, has a long history of outside influence from Arabian, Persian, Indian, Chinese, and Islamic cultures through exploration and trade.

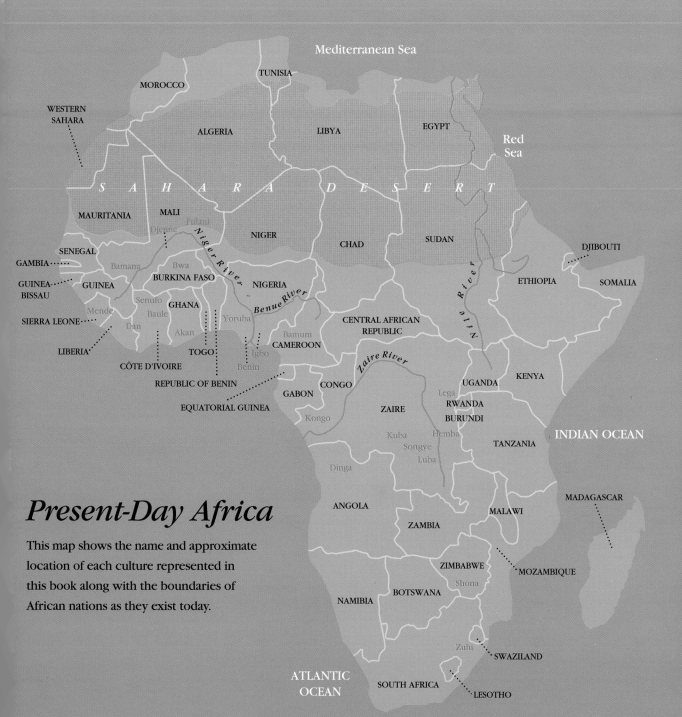

Mediterranean Sea

MOROCCO
TUNISIA

WESTERN
SAHARA

ALGERIA
LIBYA
EGYPT

Red
Sea

S A H A R A D E S E R T

MAURITANIA
MALI
Djenne Fulani

NIGER
CHAD
SUDAN

DJIBOUTI

SENEGAL
Bamana
Bwa
ETHIOPIA
SOMALIA

GAMBIA

GUINEA-
BISSAU
GUINEA
BURKINA FASO

Niger River

NIGERIA

Benue River

Senufo
GHANA
SIERRA LEONE
Mende
Baule
Yoruba
Akan
Dan

LIBERIA
TOGO
Bamum
CAMEROON
CENTRAL AFRICAN
REPUBLIC

CÔTE D'IVOIRE
Igbo
Benin

REPUBLIC OF BENIN
GABON
CONGO
Zaire River
UGANDA
KENYA

EQUATORIAL GUINEA
Kongo
ZAIRE
Lega
RWANDA
BURUNDI

Kuba
Hemba
TANZANIA
INDIAN OCEAN

Songye
Luba

Dinga

Present-Day Africa

This map shows the name and approximate
location of each culture represented in
this book along with the boundaries of
African nations as they exist today.

ANGOLA
MALAWI
MADAGASCAR

ZAMBIA

ZIMBABWE
MOZAMBIQUE

Shona

NAMIBIA
BOTSWANA

Zulu
SWAZILAND

ATLANTIC
OCEAN
SOUTH AFRICA
LESOTHO

Inner Spirit Made Visible

The Human Figure

A Radiant Vessel for the Immortal Soul

This elegant memorial head provides a dwelling-place for the spirit of a royal ancestor to help preserve the collective soul of the kingdom.

When death claims a member of an Akan royal family, a woman fashions a memorial head or statue of clay. Commemorative portraits such as this are meant to house the eternal spirit of the deceased and to ensure the continuity of a kingdom's spiritual force, known as its "kra." During memorial rites, which take place over an extended period, the image is carried in public procession through the village, set on an altar, and ultimately placed in a mausoleum or a sacred grove of trees.

Even though its original smooth surface has been worn away due to long exposure to the elements, this handsome work shows the refined modeling of the face and attention to detail that are found in only the finest memorial portraits. The woman's serene yet radiant appearance evokes the noble character of a queen mother or other woman of the royal court. Although the features may have been enhanced, Akan sculptors insist that these portraits are realistic, so we can assume that the elaborate coiffure with spiral curls very likely reflects the favorite hairstyle of the person commemorated by this sculpture.

❋ ❋ ❋ ❋ ❋ ❋ ❋ ❋ ❋ ❋ ❋ ❋ ❋ ❋ ❋ ❋ ❋

TITLE: Memorial Portrait Head
MATERIALS: terra cotta with traces of pigment
SIZE: 11 inches high (28 cm)
DATE: approx. 17th century

CULTURE: Akan
LOCATION: Ghana

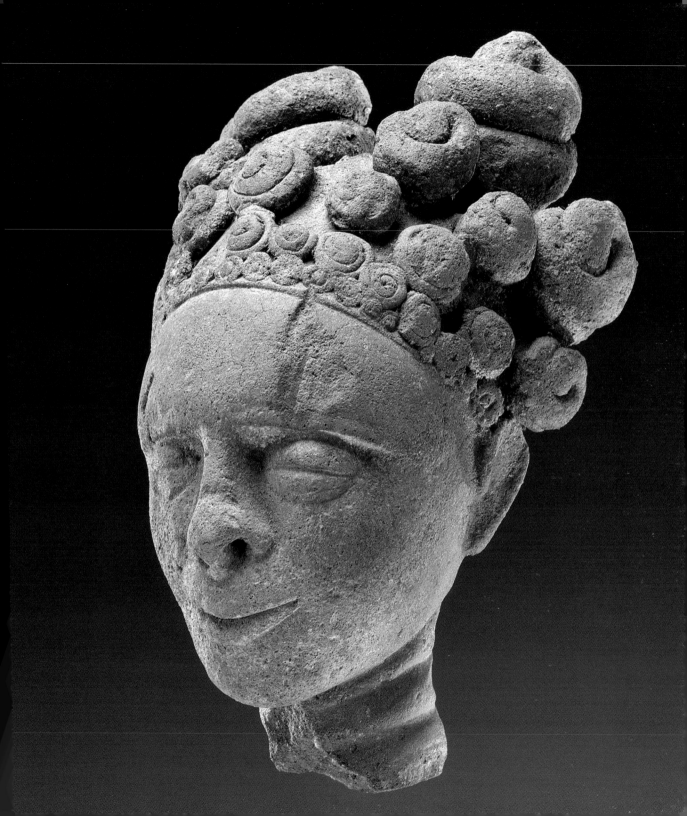

MOTHER AND CHILD, Kongo culture

At a Crossroad of Life and Death

Deep concern for the survival of her child shows in the mother's kneeling reverence and steadfast gaze.

The Kongo people are noted for creating sculptures that are visually compelling and wield mysterious powers. The carver who made this figure hollowed out the back and the head. An "nganga," or priest, placed special medicines, or "charges," inside these cavities, to empower the statue with supernatural force.

This statue demonstrates a problem. A kneeling mother raises her male child to her breast. Though grasping the breast with his left hand, the child refuses to nurse and turns his head away. His right hand is placed on his stomach, indicating a disturbance within his body. Through the powers of its medicinal charges, this statue served as a medium for revealing the source of the baby's illness. Because of its power to reveal the problem, this figure is called a mystic mirror, or *nkisi lumweno* (*nkisi* = controlling spirit; *lumweno* = mystic mirror in which visions are reflected or revealed). Perhaps an unstable family situation or a family member who is ritually impure

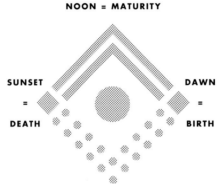

NOON = MATURITY

SUNSET = **= DAWN**

DEATH **BIRTH**

MIDNIGHT = REALM of the ANCESTORS

will be identified as the cause of the problem. With the problem revealed, a cure can be proposed.

The focus on life and death is echoed in the diamond-shaped design around the mother's navel (see diagram). The same shape repeated on each shoulder is the Kongo symbol for the life cycle. Its four points refer to the stages of life as seen in the phases of the sun. A pair of lines connects the four points, to show that the child is part of the two families of the parents. The solid lines in the upper half of the diagram denote

that people are together while they are living. The dotted lines in the lower half represent ancestors, who depart the world of the living one by one, until they return by being reborn. Additional diamonds accent the points of dawn and sunset —birth and death—to highlight the crisis that involves the child. The artist has shown the mother kneeling on her left knee, the side of life and of birth, while the child's body parallels the line from midnight, the realm of the ancestors, to dawn and birth, poignantly linking these two figures to the diagram of the life cycle.

❋ ❋ ❋ ❋ ❋ ❋ ❋ ❋ ❋ ❋ ❋ ❋ ❋ ❋ ❋ ❋ ❋

TITLE: Mother and Child
MATERIALS: wood, glass, paint, white clay, camwood powder
SIZE: 19½ inches high (49.5 cm)
DATE: approx. 19th century

CULTURE: Kongo
LOCATION: Zaire, Angola, Congo

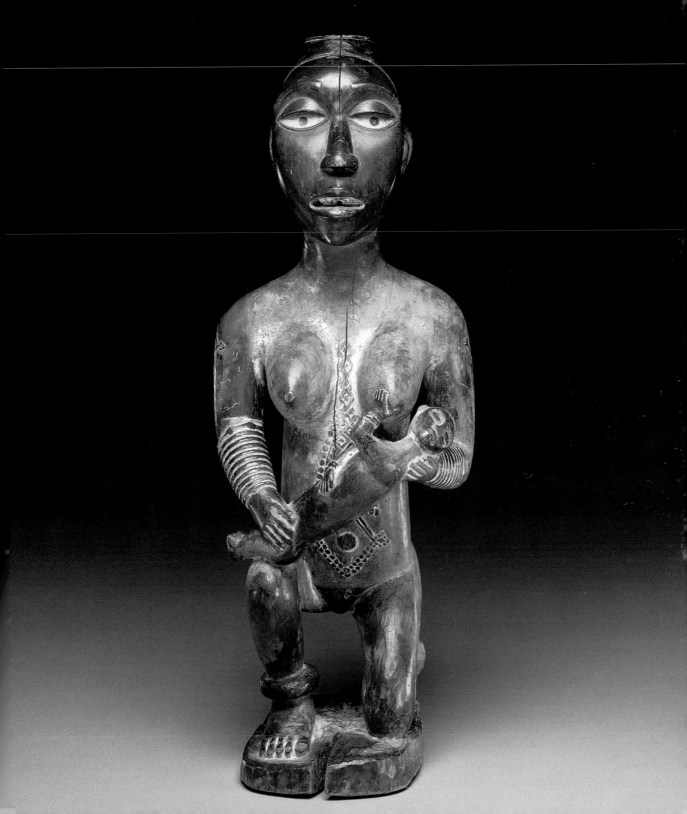

STANDING FEMALE FIGURE, Akan culture

A Well of Fresh Water

With a proud expression, elegantly styled hair, and an emphatic gesture toward the abdomen, symbol of life-giving powers, this image of woman proclaims vigor and abundance.

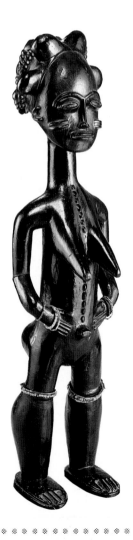

Strength, dignity, and stability: qualities of womanhood esteemed by the Akan people. They say that a woman must be "strong and solidly rooted on the earth, but upright on it." The figure's powerful legs and exaggerated feet display strength and firm planting, while its erect posture and long, arching back and neck demonstrate the vibrant character so prized by the Akan.

Women are highly regarded in Akan society. Royal lineage follows the female line, and this figure's emphatic gesture, with its hands on its abdomen, reminds us that woman is the source of life or, according to Akan proverbs, "the well of fresh water" (the source of future kings). This statue was made for an altar in a shrine. Many Akan shrines deal directly or indirectly with the subject of fertility and the figures placed on them are mostly female, thus confirming the venerated status of women.

With its dramatic, polished black surface, this image of woman is elegant and cool, its attitude indifferent and self-assured. Most striking of all is the extraordinary coiffure that frames the face, with elaborately sculpted braids or locks that cascade down the back of the head.

❋ ❋ ❋ ❋ ❋ ❋ ❋ ❋ ❋ ❋ ❋ ❋ ❋ ❋ ❋ ❋ ❋

TITLE: Standing Female Figure
MATERIALS: wood, glass beads, string
SIZE: 24 inches high (61 cm)
DATE: approx. 19th-20th century

CULTURE: Akan
LOCATION: Ghana

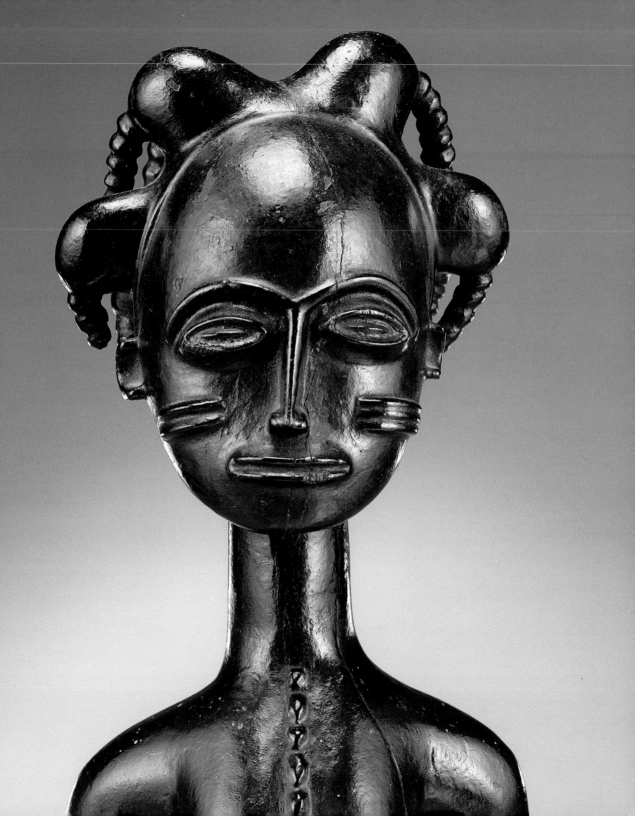

Authority in Bearing and Regalia

An important leader is memorialized in this bronze plaque, which once decorated a pillar of the royal palace in the city of Benin.

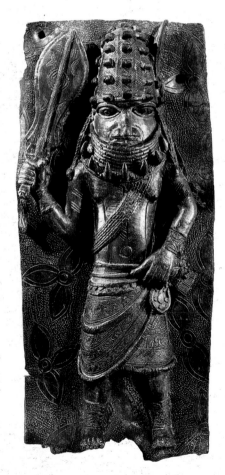

Artists of the royal court of Benin are renowned for creating plaques that document people and events in the royal court, and for making magnificent portrait heads of the Obas (divine kings). These bronze works provide a lasting record of the Benin ruling class, whose kingdom began in the tenth century. The Benin learned bronze casting from the neighboring kingdom of Ife during the fourteenth century. This figure's strong forms and crisp details reveal the mastery achieved by royal court sculptors in Benin city during their peak years of production, the sixteenth through the eighteenth centuries.

As he asserts his command through an intense gaze and raised sword, this important chieftain stands confidently with his feet squarely planted apart. So intent was the artist upon depicting every detail that the long braided tassels hanging from the chief's crown and the decorations on his bracelets are each crisply defined. Rendered with equal precision, the rest of his regalia includes a choker of coral beads, a necklace of leopard's teeth, a leopard mask on his left hip, a tall crown, beaded sash, and a finely embroidered wrap. In addition to the visual power of the image itself, the plaque is also thought to manifest spiritual power, because the metal is mysteriously transformed during the process of refining and casting.

❈ ❈ ❈ ❈ ❈ ❈ ❈ ❈ ❈ ❈ ❈ ❈ ❈ ❈ ❈ ❈ ❈

TITLE: Plaque of a Chief
MATERIALS: copper alloy
SIZE: 14³/₄ inches high (37.4 cm)
DATE: approx. 1590-1650

CULTURE: Benin
LOCATION: Nigeria

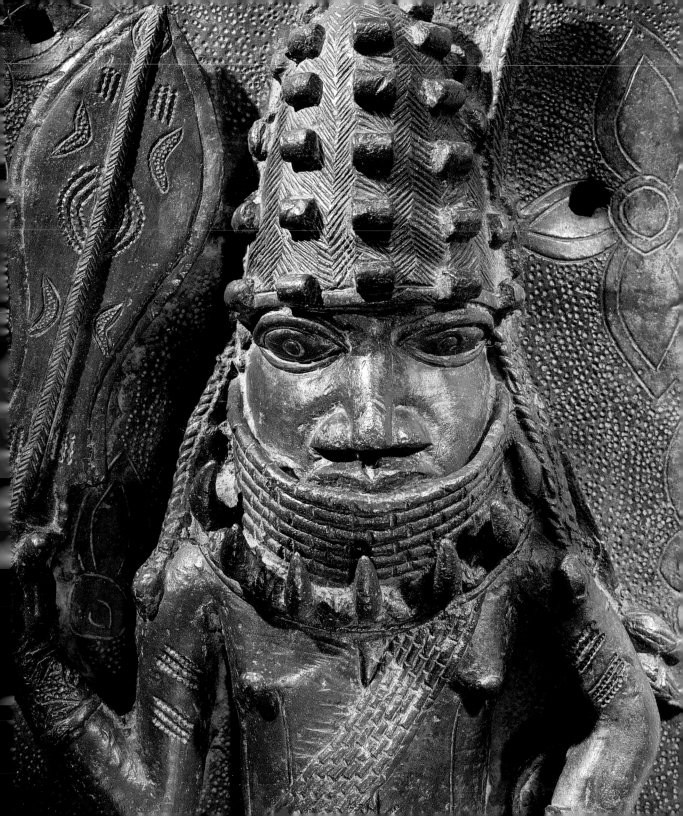

A Guardian-Ancestor of the Community

A great chief continues to protect his community from beyond the grave by means of a statue infused with potent ingredients.

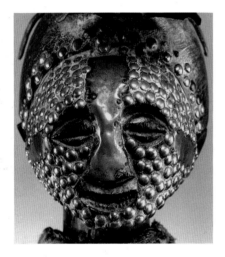

To ensure the well-being of the community, the Songye, who live in eastern Zaire, make large figures covered with a variety of natural and man-made materials. Because these "power figures" or *nkisi* represent heroic ancestors, they also record Songye history. Such figures are made many years after the death of a great chief. The raffia-cloth skirt and glass-bead necklaces, together with a long feather headdress (now missing), imitate a chief's regalia. The iron hoe blade, embedded in the forehead, denotes metalsmithing, agriculture, and community prosperity, while the copper and brass applied to the face indicate the power to direct lightning against an enemy or other source of evil. The horn projecting from the top of the head refers to the wisdom of the elders.

The statue's power does not derive from its visible attachments, but rather from the special ingredients (called *bishimba*) that have been packed into cavities in the abdomen, shoulders, and hips, and inside the horn on top of the head. Figures like this are carved by a sculptor according to detailed instructions from an *nganga,* one who is steeped in mystical knowledge and able to manipulate the special "medicines" inserted in the statue. It is the *nganga,* rather than the carver, who is credited with creating the power figure, since it is he who adds the magical substances that give the statue its awesome powers.

Songye figures are among the most forceful, awesome-looking sculptures made anywhere in Africa. Whether it be the projecting horn and hoe blade or the strong, square shoulders, this figure is robust and assertive. Even though it is meant to benefit the community, the statue is treated with great care and respect for its potency. Its role as community guardian is also expressed by the hands, which are placed on the pregnant-looking abdomen. This reference to pregnancy on a male figure is a metaphor for the important role this ancestor plays in assuring the future of the community.

TITLE: Community Power Figure
MATERIALS: wood, horn, iron, copper, brass tacks, glass beads, string, hide, raffia cloth, other substances
SIZE: 32¾ inches high (83.2 cm)
DATE: approx. 19th-20th century

CULTURE: Songye
LOCATION: Zaire

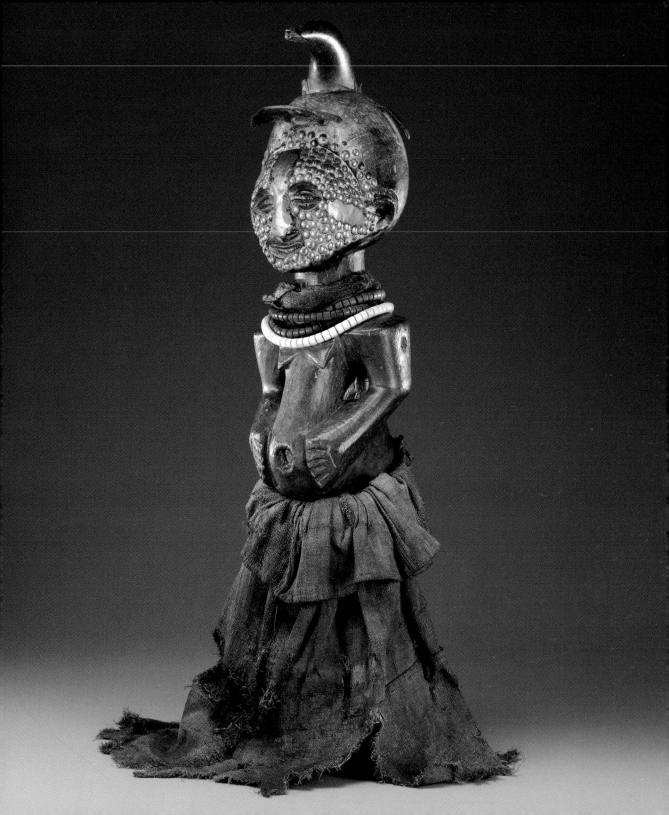

KNEELING MALE FIGURE, unidentified culture, Djenne region, inland delta of the Niger River

With Respect to a Higher Power

Although little is known about the ancient people for whom this statue was made, the figure's kneeling pose and upward gaze convey an attitude of humility and respect that endures through time.

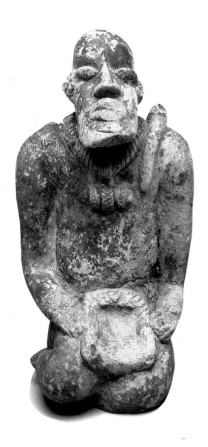

The great Niger River and its tributary, the Bani, form a broad inland delta in Mali. This region has been a crossroads of culture and trade for two thousand years or more. Along the southern reach of the delta, the ancient site of Jenne-Jeno, near present-day Djenne, was inhabited as early as the third century B.C. This important trading city developed strong ties with its sister city of trade, the legendary Timbuktu, at the edge of the Sahara, more than 250 miles down river. With the river as their highway, merchants of the two cities traded many goods, including gold, iron, copper, ivory, pepper, salt, fabrics, and glass beads, between West Africa and caravans crossing the Sahara Desert.

The Niger's inland delta is part of a broad region long inhabited by people who speak the Mande language. The first great West African empire, Wagadu, or Ghana, was formed nearby some time before the seventh century and continued until its destruction at the hands of the Islamic Almoravid dynasty

in 1067. By the 1200s the empire of Mali rose and spread more than a thousand miles from east to west. In turn, Mali gave way to the Songhai empire in the fifteenth century, and by the end of the sixteenth century, the region came under the influence of the Moors, from North Africa.

In recent decades, archaeologists working in the area of the inland delta have uncovered what remains of an extraordinary tradition of terra cotta statuary that lasted from around the tenth to the early eighteenth century. This figure's kneeling pose, common in these ancient works, suggests reverence and humility. Its heavenward gaze conveys a calm spirituality.

❈ ❈ ❈ ❈ ❈ ❈ ❈ ❈ ❈ ❈ ❈ ❈ ❈ ❈ ❈ ❈ ❈ ❈

TITLE: Kneeling Male Figure
MATERIALS: terra cotta
SIZE: 10 1/2 inches high (26.6 cm)
DATE: around 17th century

CULTURE: unidentified
LOCATION: Djenne region, inland delta of the Niger River, Mali

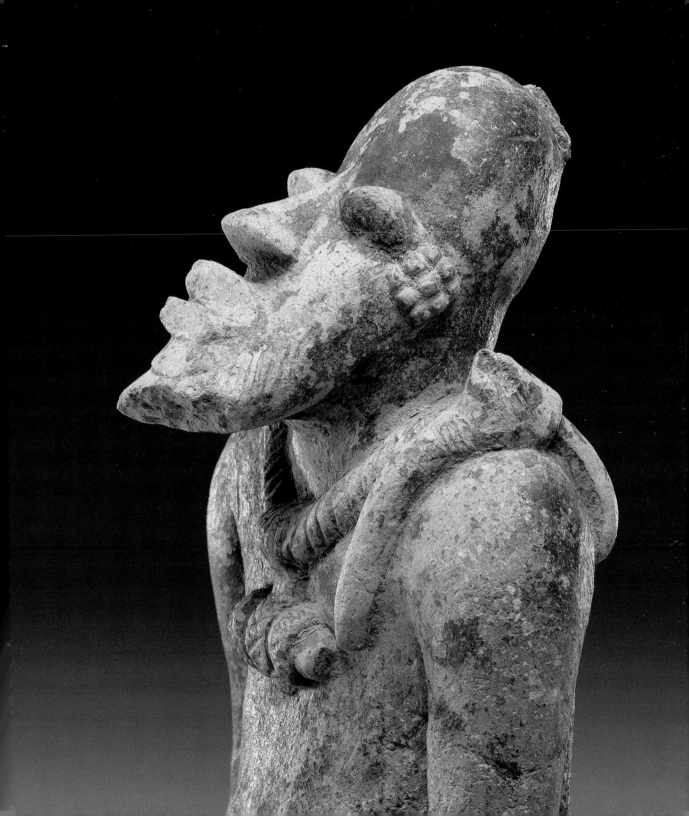

Eloquent Possessions

Symbols of Status
in the Community

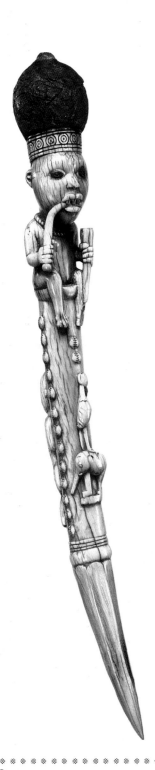

ROYAL SCEPTER, Kongo culture

Sign of Civil Authority and Supernatural Power

In its references to worldly command and mystical abilities, this scepter reveals that its owner was an important Kongo ruler.

This richly carved ivory scepter is the most important symbol of a Kongo chief's authority. It abounds with signs of his rank, starting with the commanding image of the chief himself. He holds a medicine horn in his left hand and chews on the root of a munkwisa plant, to activate its curative power. Munkwisa, a plant of the ginger family, is an ingredient in medicinal brews. Its root, a sign of authority and purity, is used in investitures to assure that the chief's power will grow from year to year. Atop his crown, a large knob of resin seals in earth that has been packed inside the head, to signify his transcendental powers. The medicine horn, the root, the crown, the earth—all proclaim the chief's importance as a spiritual leader and as a special type of *nganga*, one who has the knowledge and skills to control magical potions.

Another reference to the chief's greatness, a large bird astride an elephant, is carved on the front of the scepter. The elephant symbolizes the chief's lordly status and the bird stands for his power to transcend the Earth. The scepter ends in a point, like a larger staff that a chief may use to stab into the ground to invoke the protective spirit of the leopard.

Kongo art is noted for its intensity of form and symbolic meaning. Every part of this scepter is infused with references to the powers of its owner. The image of the chief himself is especially intense, with eyes that glare strongly and steadily forward. The head is large in relation to his body, but this is typical in African art, where importance is indicated by size. Superbly carved and richly detailed, this small image of a chief communicates with great power and boldness.

* * * * * * * * * * * * * * * * * * *

TITLE: Royal Scepter
MATERIALS: ivory, iron, earth, resin
SIZE: 18 1/2 inches high (47 cm)
DATE: 19th century

CULTURE: Kongo
LOCATION: Zaire, Angola, Congo

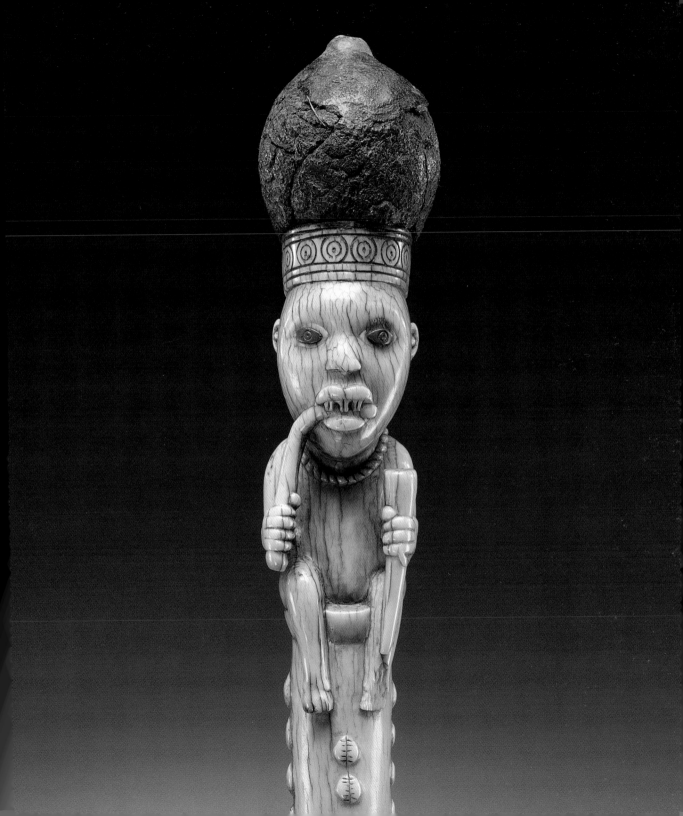

ESHU STAFF, Yoruba culture

Messenger Between Heaven and Earth

Eshu's two faces, linked by a dramatic arc, represent his mysterious travels between Earth and the spirit world, to mediate between humans and deities.

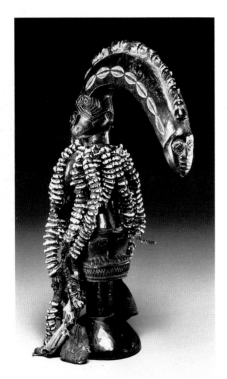

The Yoruba universe is divided into two distinct, but interconnected, realms. *Orun,* the sky, is the invisible domain of the ancestors, gods, and spirits. *Aye,* earth and water, is the visible world of the living. Among the inhabitants of the spirit-world are benevolent deities, the *orisha,* and troublesome ones, the *ajogun.* The universe is filled with tension between the *orisha* and *ajogun,* and between *ajogun* and humans.

At the threshold between these two realms are two spirits, *Eshu* and *Orunmila,* who help resolve differences between the gods and humans. Messenger, magician, trickster, and guardian of ritual, *Eshu* intercedes on behalf of humans to resolve conflicts. His help is crucial to a person's success in life and to one's relationship with the gods. If not treated properly, *Eshu* the trickster can also cause trouble.

In his role as messenger, *Eshu* attracts attention by sounding a flute, as he is shown doing in this dramatic staff. At the far end of the long arc projecting from *Eshu*'s head is a second face,

representing his appearance in the spirit world. The two faces evoke *Eshu*'s passage between Earth and Sky, *Orun* and *Aye,* communicating in both worlds. When the staff is in use, it is hooked over the shoulder, with one face looking forward and the other looking back. Carved along the arc are gourds filled with *oogun,* the medicine with the power to transform. The cowrie shells carved into the sides of the arc, the shells hanging from *Eshu*'s shoulders, and the other beads and small sacks are all signs of wealth and power, meant to impress someone to follow *Eshu*'s lead.

❋ ❋ ❋ ❋ ❋ ❋ ❋ ❋ ❋ ❋ ❋ ❋ ❋ ❋ ❋ ❋ ❋ ❋

TITLE: Eshu Staff
MATERIALS: wood, cowrie shells, glass beads, string, cloth, seeds
SIZE: 15⅜ inches high (39 cm)
DATE: 19th-20th century

CULTURE: Yoruba
LOCATION: Nigeria, Republic of Benin

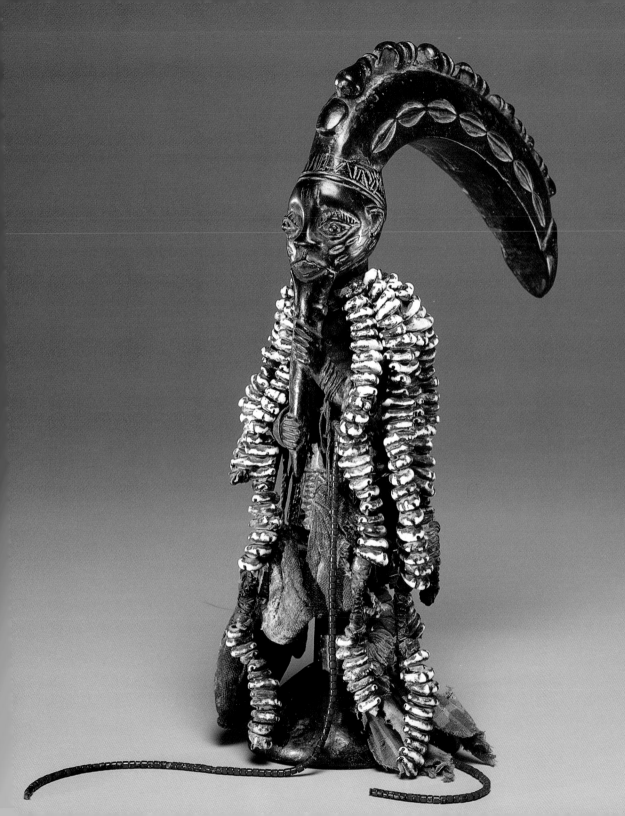

The Ritual Way

Five compartments in this box store a diviner's implements while the carvings on its lid depict human characters, spirits, and rituals.

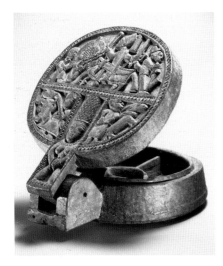

While the divine messenger *Eshu* is a trickster who can create chaos and expose evil, *Orunmila* is a god of wisdom who helps to establish order and peace. *Orunmila* acts through an oracle, or diviner, who helps a person understand how supernatural forces work in his or her life and how to influence their outcome through prayer and sacrifice. The Yoruba people call this system of interpreting the ways of the gods, or divination, "Ifa." A diviner stores his accessories in a box, such as this one, its heavy lid richly carved with images relating to *Ifa* divination. On the upper half of the lid, a warrior on horseback is flanked by none other than *Eshu*, seen in two forms, as he is on the staff shown on the preceding page. To the left, *Eshu* sounds his flute to signal the warrior's sacrifices, which we see being prepared on the lower panels. To the right, *Eshu* leans casually, almost mockingly, against the horse's flanks as he smokes his pipe.

The female figure below represents an island of calm amid the bustling activity shown around her, reinforcing the contrast between order and chaos that *Orunmila* and *Eshu* represent.

⁕ ⁕ ⁕ ⁕ ⁕ ⁕ ⁕ ⁕ ⁕ ⁕ ⁕ ⁕ ⁕ ⁕ ⁕ ⁕ ⁕ ⁕

TITLE: Ifa Diviner's Box
MATERIALS: wood
SIZE: 24½ inches high (62.2 cm)
DATE: late 19th–early 20th century

CULTURE: Yoruba
LOCATION: Nigeria, Republic of Benin

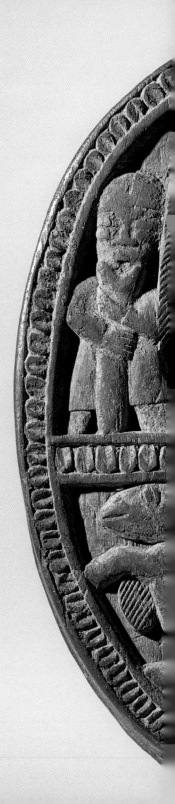

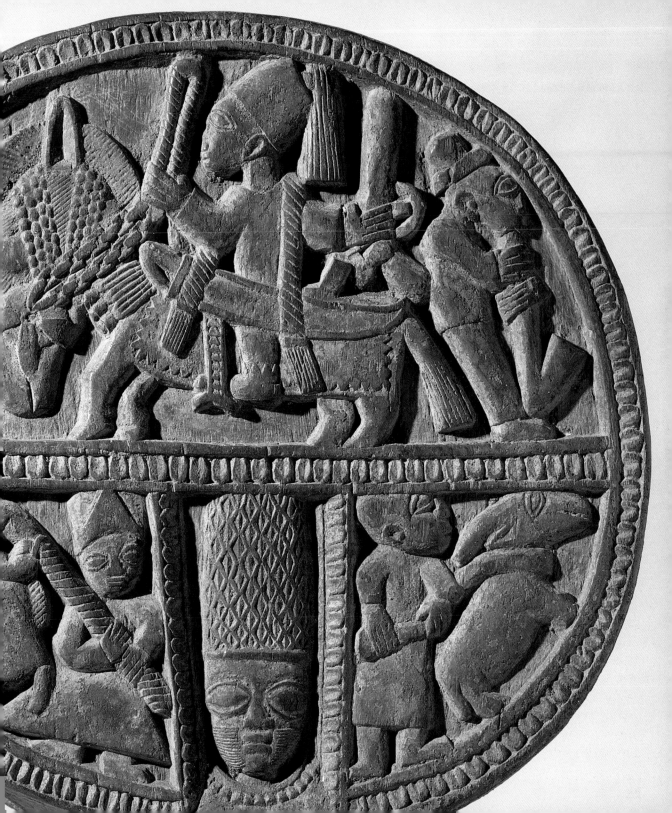

Bearing the White Clay of Purification

The figure of a woman holding a bowl, used in the ritual of royal investiture, is an important emblem of a Luba king.

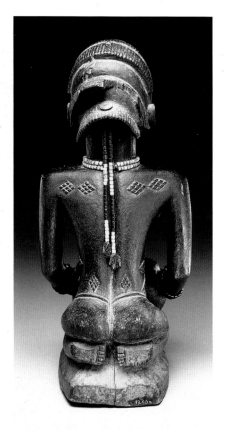

During special ceremonies among the Luba, a diviner who can communicate with the spirits of the ancestors fills a dried calabash (gourd) with sacred white clay and sends it to a king. This white clay, or kaolin, used in ceremonies, is stored here in a bowl held by a carved figure that may represent the king's wife. This figure has a strong, upright posture. Her waist is drawn in and her chest thrust out, as if she has just taken a deep breath. Details such as these animate the figure with a vibrant sense of life.

Other details of the figure speak eloquently about Luba beliefs and traditions. For example, the figure's black finish and the way the front teeth have been filed refer to the Luba myth of their origins. *Nkongolo,* a fierce Luba warlord, was noted for his cruelty. He had reddish skin and wherever he went he left the land red from the blood of his victims, spilled in his conquests. Later the wandering hunter *Mbidi Kiluwe* entered Luba country and introduced *Nkongolo* and his family to more

civilized behavior. *Mbidi Kiluwe*'s skin was very black and his front teeth were filed. Thus these two traits—seen clearly in this statue—became important signs of refinement for the Luba.

❋ ❋ ❋ ❋ ❋ ❋ ❋ ❋ ❋ ❋ ❋ ❋ ❋ ❋ ❋ ❋ ❋ ❋

TITLE: Kneeling Woman Holding a Bowl
MATERIALS: wood, cloth, string, glass beads, button, brass tacks, Belgian colonial currency
SIZE: 18¼ inches high (46 cm)
DATE: approx. 19th century

CULTURE: Luba
LOCATION: Zaire

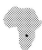

A Link Between the Ancestors and the Living

The continuity of the Luba kingdom is symbolized by the figure of a robust young woman who holds the seat of a royal stool above her head.

The Luba people can be traced back at least as far as the sixth century, and they emerged as a consolidated empire during the sixteenth century. Women play a central role in many Luba myths, and they hold positions of great honor in their social and political order. Accordingly, woman is the primary subject of their art.

The design of this stool expresses an important concept held by the Luba, one that might be called the "unbroken chain of life." For the Luba, life comes from God and it is mankind's responsibility to seek its expansion on earth. According to Luba belief, the greatest ill that can befall anyone, man or woman, is not poverty or death, but being childless.

For this heraldic stool, the carver has made the figure's legs smaller in order to show her womb as close as possible to the Earth, home of the ancestors; by emphasizing her gently swollen abdomen, the artist alludes to her role as childbearer; and finally, through her long, straight, upraised arms, the artist emphasizes her role of supporting the

living leader. Thus the base, the figure, and the seat symbolically connect the ancestors with the living, while the female figure, who provides support, becomes the essential link in this unbroken chain of life. The cycle of life is symbolized in the pattern of scarification around her navel, as shown in the diagram above. Like the pattern on the Kongo figure of mother and child in Chapter 1, the four points of this pattern refer to the stages of life through the metaphor of the sun: dawn and birth are to the right, noon and maturity are to the top, sunset and death are to the left; and midnight and the realm of the ancestors are to the bottom.

TITLE: Royal Stool
MATERIALS: wood, glass beads, string
SIZE: 16 ¾ inches high (42.5 cm)
DATE: 19th-20th century

CULTURE: Luba
LOCATION: Zaire

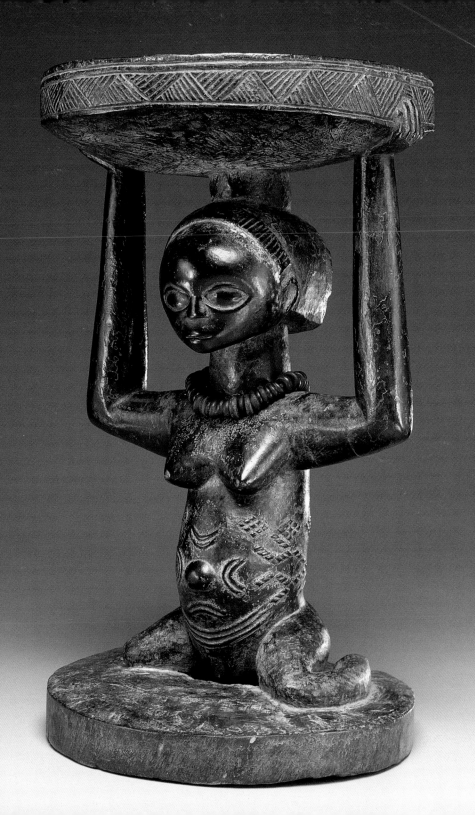

To Herald the Presence of a Chief

From the tusk of a majestic elephant, lord of Africa's animal kingdom, comes the ivory for a trumpet to announce a great chief.

When a high chief of the Mende people enters a village or presides at a ceremony, signs of his or her greatness are demonstrated through magnificent regalia carried by royal attendants. As part of this treasure, ivory trumpets fill the air with the call of the chief's presence. A small opening has been cut into the long, hollowed-out tusk of an elephant, and a resonant tone is created when the player blows into the aperture. With great wit, the hole has been carved into the figure's chest, exactly where the lungs would be. A fine example of the Mende love of beauty, the rich embellishment of this trumpet includes an elegantly dressed woman who has a game board on her lap. Wearing bracelets, a dress with lace-like trim, and a "pill-box" style hat over a layered coiffure, this figure may represent an ideal of feminine beauty. The game board is readily identified as a form of *mankala.* Possibly one of the oldest games and the one most widely played throughout the world, *mankala* requires great intellectual ability and exacting concentration. Playing the game is often associated with membership in special clubs, and in some African societies, the very ownership of a game board is restricted to royalty and others in positions of authority.

Women can hold high office in Mende society, including that of paramount chief, who rules over several villages. The female figure carved on this horn may represent either a chief or a member of the royal court. Surprisingly, British heraldic insignia—the lion and the crown—are carved on the sides of the horn. In 1896, Great Britain established peaceful treaties with the Mende that remained in effect until about 1910. The British lion and crown on the lower sides of the horn probably refer to this alliance and make it possible to date the horn to this period of Mende history.

❋ ❋ ❋ ❋ ❋ ❋ ❋ ❋ ❋ ❋ ❋ ❋ ❋ ❋ ❋ ❋

TITLE: Trumpet
MATERIALS: ivory, brass, shell inlay
SIZE: 27 1/2 inches high (70 cm)
DATE: approx. 1900

CULTURE: Mende
LOCATION: Sierra Leone

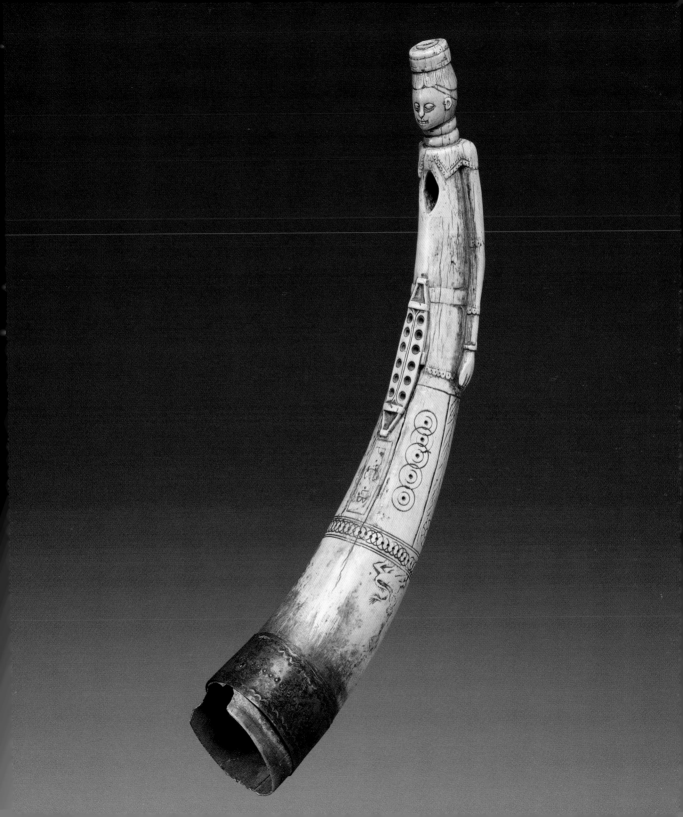

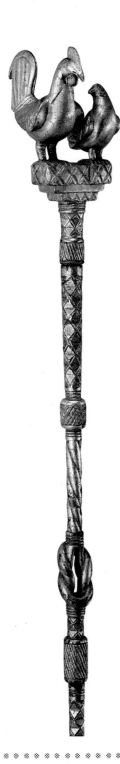

Royal Status Announced by a Proverb

"Although the hen knows that the dawn is breaking, she leaves it to the rooster to announce." — Akan proverb

The Asante, the largest kingdom of the Akan culture, are noted for their vast repertoire of proverbs that linguists, the royal speechmakers, use in discourse. Linguists are trained orators who speak on behalf of a king. They are also important counselors, ambassadors, and historians for the royal court. An ornate staff with a sculpted finial, such as this one, is a symbol of the linguist's royal office.

Proverbs are often illustrated in Akan ritual objects, and proverbs asserting the power of the ruling elite usually decorate court regalia. The hen and the rooster on this staff poignantly but clearly convey authority in speech on this linguist's staff.

Among the Asante, ownership of gold or gold-leafed objects is strictly controlled by the king. Asante artists are renowned for their ability to fashion exquisite works in gold, which they make to fulfill the needs of members of the royal court. They cast some of their gold objects by pouring molten gold into a mold; others are made by *repoussé*, by which thin sheets of gold are hammered into shapes and patterns. This staff is made of carved wood that has been gilded by covering every surface with paper-thin sheets of gold.

TITLE: Royal Linguist's Staff
MATERIALS: wood, gold leaf
SIZE: 65 1/2 inches high (166.4 cm)
DATE: 20th century

CULTURE: Akan (Asante kingdom)
LOCATION: Ghana

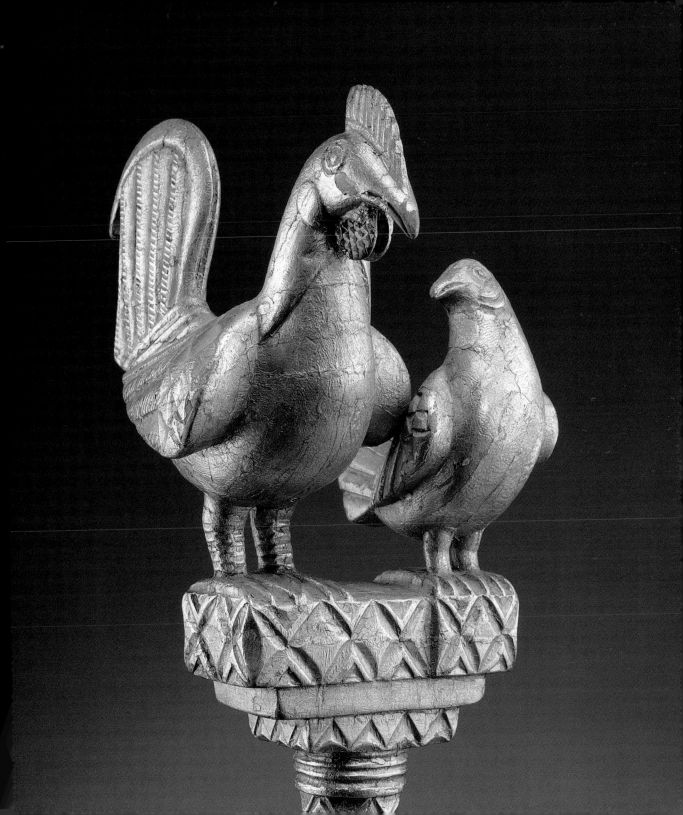

NECKLACE, Akan culture

Adornment for a Queen-Mother

Accompanied by tiny golden bells to rouse the spirit, and rings of gold to indicate purity, the pendant of a small freshwater crab lets it be known that the wearer of this fine necklace is the mother of the king.

The Asante are famous for their craftsmanship and trade in gold, which earned their homeland its former name, the Gold Coast. Objects of gold signify wealth and status among the Asante, and gold is also thought to protect those who wear it.

Bells, disks, and cross-shaped beads are strung together to make up this beautiful necklace. Each element has been made by casting molten gold in the lost-wax process. To do this, bells, disks, and crosses are shaped in wax, then a heat-resistant mold is formed around the wax. When the mold is heated, the melted wax runs out, and molten gold is poured in its place. When the gold has cooled, the mold is taken apart to reveal the lovely cast-gold object. The highlight of this necklace is a solid gold pendant in the form of a small freshwater crab, made from a mold formed directly around a live crab. In Asante proverbs, the freshwater crab symbolizes the queen mother, so from this we know the royal status of its wearer.

❋ ❋ ❋ ❋ ❋ ❋ ❋ ❋ ❋ ❋ ❋ ❋ ❋ ❋ ❋ ❋ ❋ ❋ ❋

TITLE: Necklace
MATERIALS: gold
SIZE: 15¾ inches long (40 cm)
DATE: 19th century
CULTURE: Akan (Asante kingdom)
LOCATION: Ghana

36

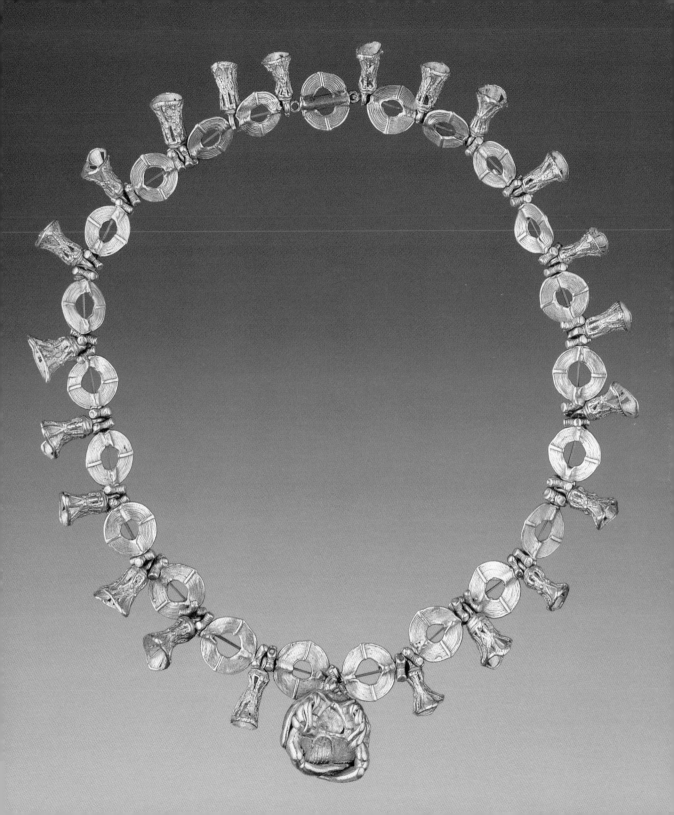

Exalting the King

When the crown is worn, the king's inner head is said to be united with the inner heads of those who reigned before him.

Yoruba artists, like the artists of many other cultures of Africa, make the head of their carved figures large in relation to the body, to help define its importance. The Yoruba consider the head to be the location of a person's essential nature, and believe they have an inner "head" that guides outward behavior.

Given the symbolic importance of the head, making a crown for a Yoruba king is a significant ritual event. Those who make the form of the crown and apply the beadwork do so in secret. Before a new crown can be worn, a packet of herbal medicines is concealed inside the top, and elaborate rituals are performed to consecrate the crown. When the crown is finally placed on a king's head, his inner being is said to become one with those who have reigned before him.

This crown is beautifully decorated with a type of very fine colored glass beads that came to West Africa in great abundance, through trade with Europeans, during the nineteenth century. The face or faces that appear on Yoruba

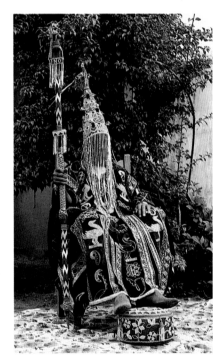

women, who help ensure the king's strong and effective reign.

❊ ❊ ❊ ❊ ❊ ❊ ❊ ❊ ❊ ❊ ❊ ❊ ❊ ❊ ❊ ❊ ❊

TITLE: Beaded Crown
MATERIALS: cloth, beads, threads
SIZE: 12 3/4 inches high (32.4 cm)
DATE: 19th-20th century

CULTURE: Yoruba
LOCATION: Nigeria, Republic of Benin

crowns have various meanings. Some Yoruba say that the face represents *Oduduwa,* the founder and first king of the Yoruba; others say it depicts the "inner face" of the king. One or more birds almost always appear on a crown. Birds refer to the mystical power of

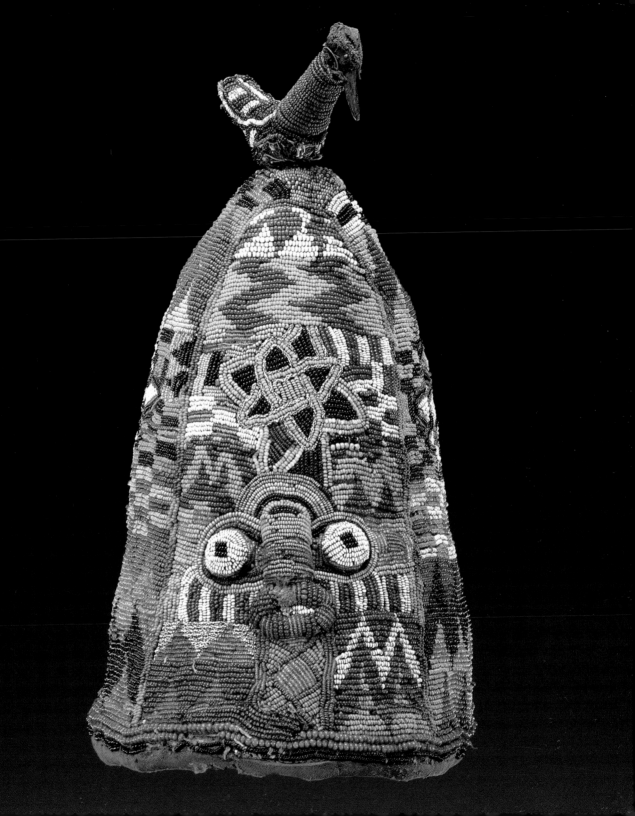

Bwami: The Fruit That Came From Above

These elaborate hats signify advancement to the highest levels of wisdom and status in the community.

The term "hat" is inadequate to describe the real significance of this headpiece, which identifies its wearer as one who has achieved the highest grade of *Bwami*, a communal society and moral philosophy to which virtually all Lega belong. *Bwami* lends structure to Lega society through a series of grades that provide lifelong goals for women and men. Those who achieve the highest grades wear hats, made of symbolic materials.

In Bwami, husbands and wives share equal status, though they participate in different rituals and wear distinct hats. The hat with cowries and elephant-tail hairs (opposite) is for the highest male grade of *Bwami*, the *Kindi*.

The highest rank of *Kindi*, who are teachers of other *Kindi*, wear special wig-like hats with fibers braided in a woman's hairstyle (near right). The braids symbolize his comprehensive human understanding, thus he has quasi-female status. Wives of these teachers also wear a special hat (far right) and have quasi-male status, symbolized by the hat's phallic shape.

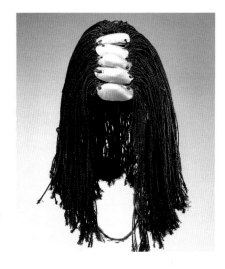

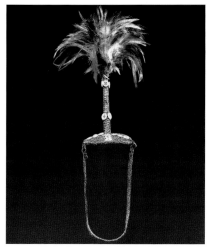

TITLE: Man's Bwami Hat
MATERIALS: woven raffia, braided fiber, mussel shells, buttons, glass beads, string
SIZE: 13 inches high (33 cm)

DATE: 19th-20th century
CULTURE: Lega
LOCATION: eastern Zaire

TITLE: Woman's Bwami Hat
MATERIALS: woven raffia, wood, buttons, feathers, string
SIZE: 16 inches high (40.6 cm)

TITLE: Man's Bwami Hat
MATERIALS: woven raffia, cowrie shells, elephant tail hair, cloth, glass beads, copper wire, string
SIZE: 14 1/2 inches high (36.8 cm)

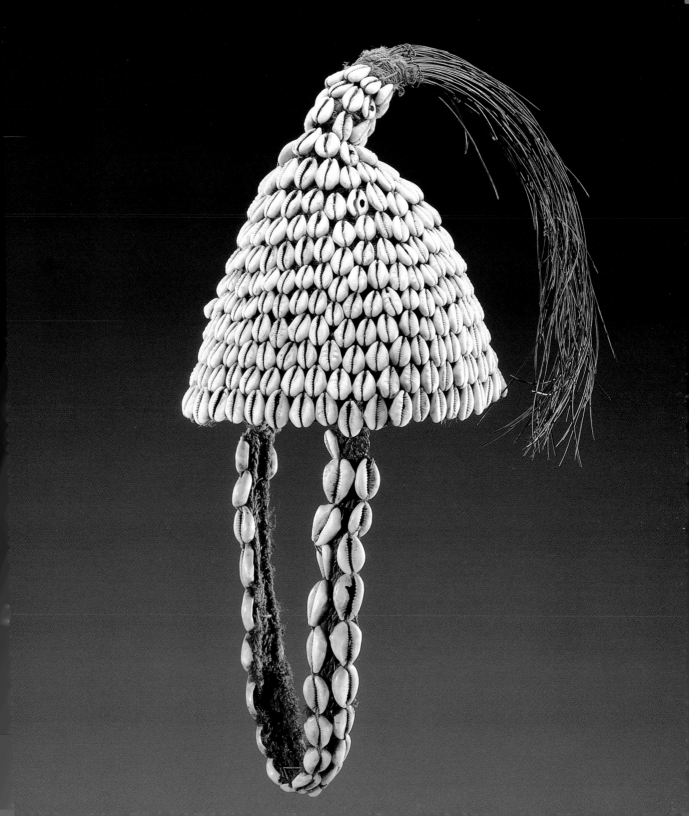

The Love of Beauty

Objects for Personal Use

From Ancient Furnaces Near the Niger River

Crafted by talented metalsmiths centuries ago, these objects have been unearthed from sites along the Niger River.

People of many cultures in Africa enjoy rich traditions of personal adornment. The way a man or woman dresses, the jewelry they wear, their hairstyling, and body markings—either done temporarily with pigments or permanently by means of scarring—can reveal many things: their status or wealth, the clan they belong to, or their individuality and their love of beauty.

Some of the oldest surviving jewelry from West Africa has been unearthed at ancient sites near the Niger River in present-day Mali. Several pieces are illustrated here, including a pair of necklaces, a small bracelet, and a large, tapered pendant that would have been hung on a necklace. These are works in copper, or mixtures of copper and tin (bronze), or copper and zinc (brass). The miniature figurines on horseback show a different kind of object made by metalsmiths of the region. Terra cotta statuary has also been found in this same area, such as the figure illustrated on page 19, which wears a necklace with a large pendant bead.

The greenish color of these works is caused by the copper reacting with other elements in the soil during their long burial in the earth. When first made, they would have been polished to a shiny golden luster.

Such carefully wrought objects offer a glimpse of the finery appreciated by people who lived hundreds of years ago in thriving centers of trade along the Niger, such as Djenne and Timbuktu. These ancient works can help us imagine how a woman looked in her glistening necklaces, earrings, and bracelets, her handsome woven garments, her fine cosmetics, and her ornately styled hair. Love of personal adornment continues today among people of the Niger River region, as can be seen in the fine gold earrings on the next page.

TITLE: Necklace
SIZE: 21 inches long (53.3 cm)

TITLE: Necklace
SIZE: 23¾ inches long (60.3 cm)

TITLE: Bracelet
SIZE: 3½ inches diameter (8.9 cm)

TITLE: Three Figurines on Horseback
SIZE: each approx. 1¾ inches high (4.4 cm)

TITLE: Pendant
SIZE: 3¾ inches wide (9.5 cm)

MATERIALS: copper alloy
DATE: 14th-18th century

CULTURE: unidentified
LOCATION: Djenne region, inland delta of Niger River, Mali

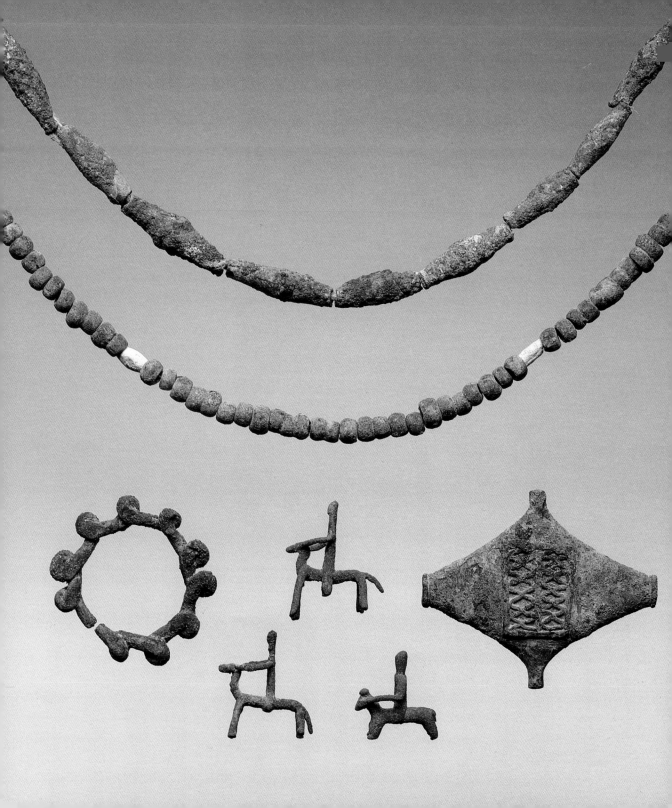

Wealth for Wearing

Her family's wealth is displayed in a Fulani woman's elegant gold earrings, one of Africa's most magnificent jewelry forms.

One of the most striking forms of jewelry in West Africa are the distinctive, four-leafed earrings worn by Fulani women who live in Mali and in other countries along the edge of the Sahara Desert. Typically these earrings are made of four thinly hammered flanges joined along a center spine. The whole design is gracefully cupped, and two stems extend from either end to penetrate the woman's pierced ear. More elaborate examples, such as this pair, have finely tooled geometric designs on the surface of the flanges.

A Fulani woman may have her gold earrings remade larger as her family acquires wealth. She wears her earrings, like her other jewelry, both to display her family's fortune and to ensure its safekeeping.

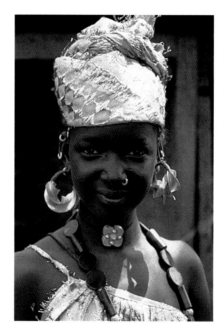

TITLE: Earrings
MATERIALS: gold
SIZE: 3 1/4 inches wide (8.3 cm)
DATE: 20th century

CULTURE: Fulani
LOCATION: Mali

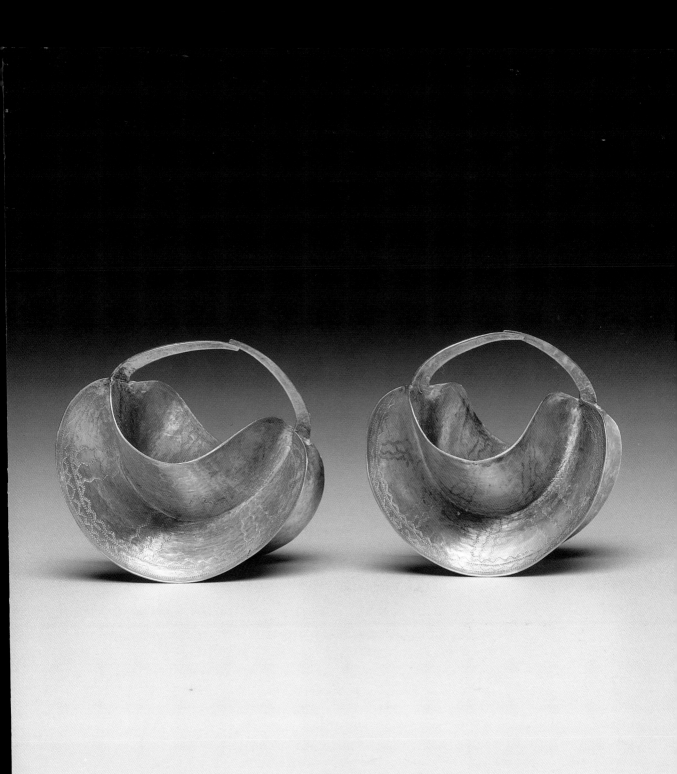

Art to Inspire Art

"Nobody likes to live without beautiful things." — West African weaver; quote recorded in 1934

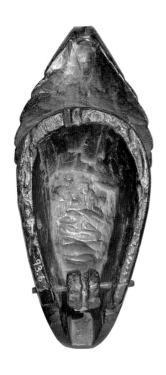

Weavers in many West African cultures create brightly patterned strip cloth on narrow looms. To raise and lower the warp threads during the weaving process, their looms require two heddles, which are operated by foot pedals linked to a pulley suspended from the top of loom.

Most strip looms are simple wooden structures, in contrast to the beautiful textiles that are so painstakingly created on them. Baule weavers, however, often attach beautifully sculpted pulleys to operate the heddles. These ornamented pulleys identify the weaver, like a sign or trademark, and they provide a sense of beauty that will inspire him in his task of transforming simple threads into an attractive cloth.

This pulley is carved in the form of a miniature face mask, thoroughly detailed with perforated ridges along the sides, where the costume would be attached to a full-sized mask. The mask probably imitates one from a society to which the weaver belongs. It is beautifully detailed and polished, and the

pulley mechanism has been deftly concealed in the hollow behind the face.

Though they may resemble other ritual objects, sculpted pulleys are purely decorative and do not serve a ritual function. For a sculptor, pulleys provide an opportunity to apply virtuoso skill and invention, and they are often the subject for artistic competitions. The resulting objects are among the most lively and exquisite Baule sculptures and they are quintessential examples of the Baule love of beauty.

TITLE: Heddle Pulley in the Form of a Mask
MATERIALS: wood, metal
SIZE: 6 1/8 inches high (15.5 cm)
DATE: 19th-20th century

CULTURE: Baule
LOCATION: Ivory Coast

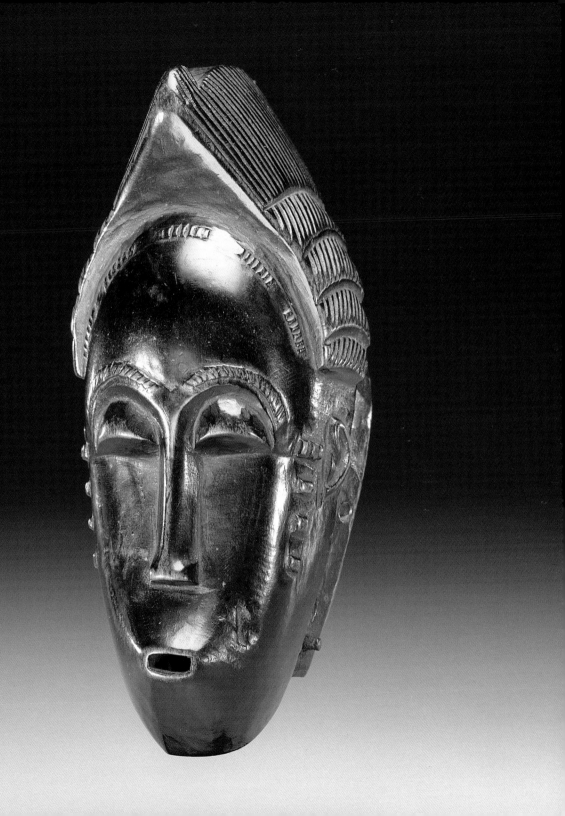

Pleasing to the Eye and the Hand

People of the Zulu culture admire elegant design and fine craftsmanship in everyday objects— serving dishes, tools and utensils, smoking pipes, and accessory boxes.

In the early 1800s a powerful young Zulu chief named Shaka established the Zulu state by unifying many smaller cultures in southeastern Africa. The brilliance of his exploits earned Shaka fame as one of the world's greatest military leaders.

In the early nineteenth century, the cultivation and use of tobacco was already popular among the Zulu. The crop had been imported from the Americas in the 1600s and snuff, powdered tobacco to be inserted in the nose, was a favorite way of using it. Sharing snuff with friends and visitors and offering it to the ancestors was considered a sign of good manners and respect.

Containers for snuff, made of small gourds elegantly decorated with patterns of fine wire, were prized by Zulu men. These attractive containers were passed down from one generation to the next, and obtained a rich luster from frequent handling and occasional applications of oil. This handsome example is decorated with the triangle, diamond, and circle motifs typical of Zulu ornament.

TITLE: Snuff Container

MATERIALS: gourd, copper and brass wire

SIZE: 2 3/4 inches high (7 cm), 3 1/4 inches diameter (8.2 cm)

DATE: 19th century

CULTURE: Zulu

LOCATION: South Africa

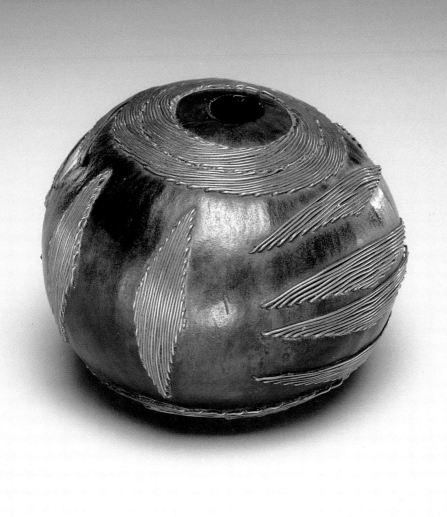

HEADREST, Shona culture

"Pillow of Dreams"

For sleeping, for dreaming, and for protecting an elegant coiffure.

Carved headrests have been used for sleeping in many regions of Africa for several thousand years. Most headrests are designed with a curving support raised above a broad base. It could be placed at the back of the neck, but most often a headrest is positioned under the ear and along the side of the jaw to cradle the whole head while sleeping on one's side (see photograph). Despite the hard surface, the cradling effect is quite comfortable, even if it does limit the sleeping positions to the side or back.

The intricate design of headrests demonstrates their importance. As a highly personal object, the headrest was for use only by the owner; not even other members of the family would use it. In fact, excavations in several areas of Africa have revealed the practice of burying the deceased with their headrests.

Besides elevating the head for comfort, a headrest also helps to protect an elaborate hairdo, thus underscoring the importance of hair styling as a sign of age, rank, or even as a magical charm.

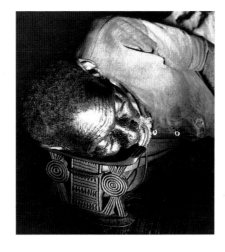

The beauty of the headrest is an appropriate complement to the hairdo.

While the design as a whole is very important, the vertical section is where master carvers have supplied the greatest invention. The raised patterns in the central discs on this example resemble traditional patterns of body scarification.

People in some African cultures believe that the dreams one has while sleeping on a headrest are revealing, and in some areas of Africa the headrest is called a "pillow of dreams."

The significance of such dreams is underscored by divination practices in which miniature headrests are part of a diviner's accessories and are used to interpret a person's problems through their dreams.

❈ ❈ ❈ ❈ ❈ ❈ ❈ ❈ ❈ ❈ ❈ ❈ ❈ ❈ ❈ ❈ ❈ ❈ ❈

TITLE: Headrest
MATERIALS: wood
SIZE: 5 5/8 inches high (14.3 cm)
DATE: 19th-20th century

CULTURE: Shona
LOCATION: Zimbabwe

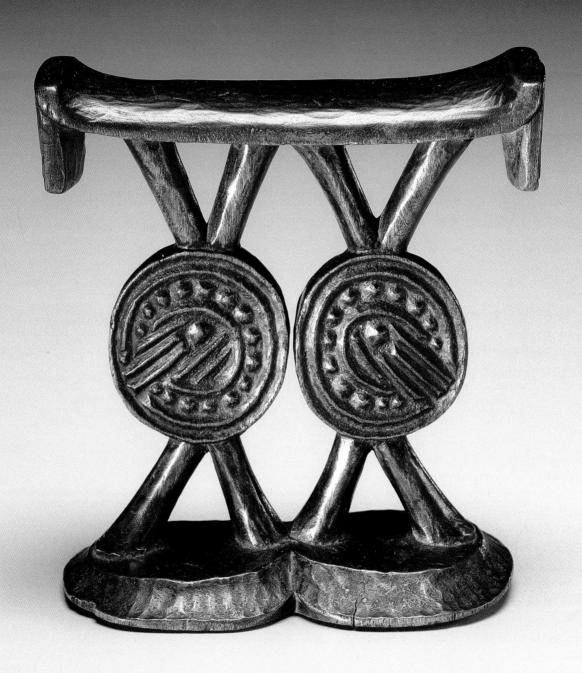

WOMAN'S WRAP SKIRT, Kuba culture

From Palm Frond to Patterned Skirt

Repetition and improvisation of a few simple forms create syncopated, jazz-like rhythms on this woman's skirt.

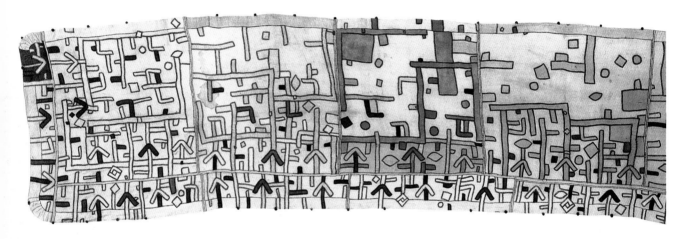

In the tropical forests of western and central Africa, the raffia palm grows in abundance. Fibers in the fronds of the palm are used to weave a fabric called raffia cloth.

Raffia fibers are prepared for weaving by drying and splitting the young leaflets of the palm. The fibers are usually about three to five feet long, which determines the size of the cloth that can be woven from them. To make a larger cloth, several smaller pieces are sewn together. This has been done to make the yardage for this Kuba woman's skirt, which is worn by wrapping

it five or six times around the waist. The lively designs on this skirt have been made by cutting shapes from other raffia-cloth panels and stitching them onto the base cloth. This process is called appliqué.

The people of the Kuba culture create perhaps the most extraordinary raffia textiles in Africa. Plain squares of raffia cloth were once a form of Kuba currency, and decorated cloths are exchanged in marital contracts and are given by villages as tribute to the king. Elaborately patterned appliqué skirts such as this are reserved for special occasions, and

they also form part of the costume of *Ngady amwaash*, the Kuba royal mask of the queen (see page 87).

❋ ❋ ❋ ❋ ❋ ❋ ❋ ❋ ❋ ❋ ❋ ❋ ❋ ❋ ❋ ❋

TITLE: Woman's Wrap Skirt
MATERIALS: raffia cloth
SIZE: 249 inches (7 yards) long (632 cm), 31 inches wide (79 cm)
DATE: 19th-20th century
CULTURE: Kuba
LOCATION: Zaire

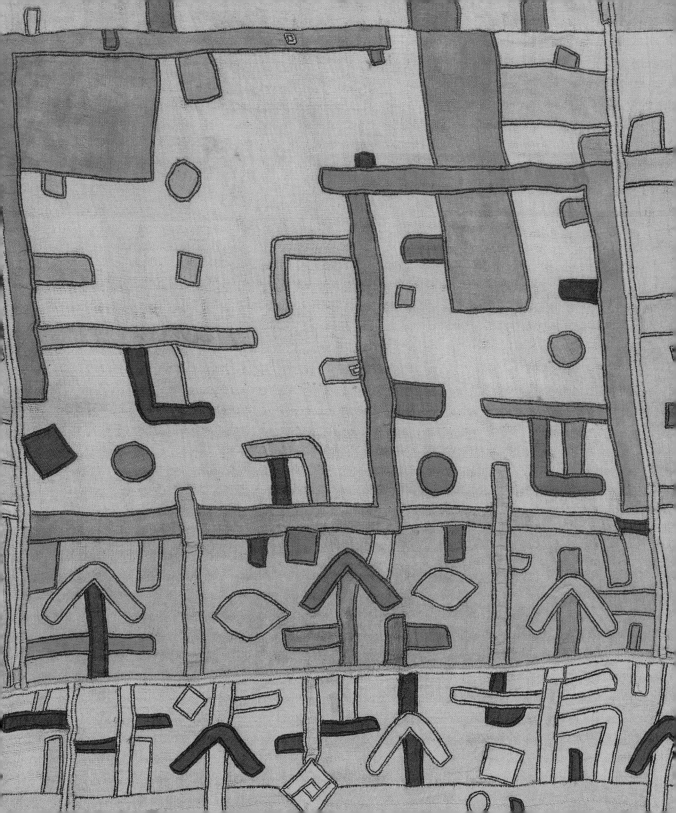

WOMAN'S WRAP SKIRT AND SHAWL, Igbo culture

Patterns in the Weave

Bright threads of red, yellow, blue, and white have been "floated" into the weave of this skirt and shawl to create eye-catching patterns on the black fabric.

Among the Igbo and other cultures in Nigeria, women weave broad cloth on a vertically mounted loom. The threads that are strung tightly between the top and bottom bars of the loom are called the warp threads. Weaving consists of interlacing the cross-threads, called the weft, between alternating warp threads. A plain-weave fabric is produced by a simple over-one/under-one interlacing of warp and weft. The process is made easier when the alternate groups of warp threads are held apart by a tool called a shedding device while the weft thread is passed through the opening.

This technique was used to create the plain-weave base fabric of the woman's wrappers illustrated here. The elaborate decorative patterns, however, were added by inserting additional weft threads, called supplementary wefts, in this case brightly colored threads of red, yellow, blue, and white. The colorful patterns stand out boldly because the supplementary threads pass over more than one warp thread at a time, producing what is called a float weave.

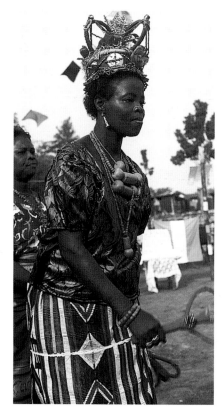

Igbo weavers of the Akwete region in southern Nigeria are renowned for producing this type of woman's wrap. Akwete cloths are highly prized and

take their name from the region where they are made. In the photograph at left, a young woman from the neighboring Ijo region in Nigeria is going through her coming-of-age ceremony. For this she is required to wear imported cloths. Around her waist is a boldly patterned Akwete skirt.

⁕ ⁕ ⁕ ⁕ ⁕ ⁕ ⁕ ⁕ ⁕ ⁕ ⁕ ⁕ ⁕ ⁕ ⁕ ⁕ ⁕ ⁕

TITLE: Woman's Wrap Skirt and Shawl
MATERIALS: cotton fibers
SIZE: Shawl: 62 inches (1 3/4 yards) long (157 cm), 36 1/2 inches wide (93 cm)
Skirt: 71 inches (2 yards) long (180 cm), 48 1/2 inches wide (123 cm)
DATE: late 19th-early 20th century

CULTURE: Igbo
LOCATION: Nigeria

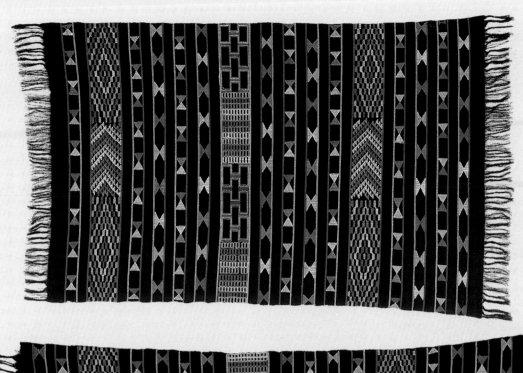
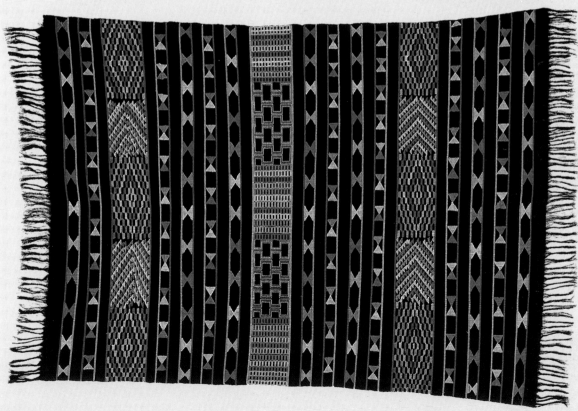

A Grand Robe with Magnificent Embroidery

One of Africa's most impressive art forms is its strikingly handsome textiles.

When a Yoruba man wears a voluminous embroidered robe, he makes an impressive and dignified appearance that expresses his status and wealth. This grand robe has been spread out to show the full extent of the intricate embroidery designs. When worn, the wide side panels would be carefully folded onto the shoulders, as can be seen in this photograph of two men wearing their robes.

Like many West African textiles, traditional Yoruba garments are fashioned from strip cloth. Yoruba men weave this cloth on narrow looms, producing long strips that are four to eight inches wide. These long strips are cut into equal lengths and then stitched together, side by side, to form larger bolts of cloth for making wraps and other garments. This robe's deep blue color, a favorite of the Yoruba, comes from dyeing the yarn in vats of indigo, a dye prepared from various plants.

The surface of the robe is richly embroidered with motifs of Yoruba and Islamic origin. Embroidery is a

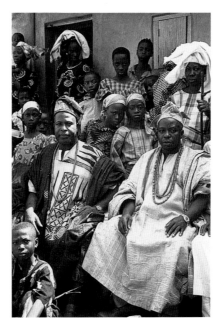

technique of decorating cloth using a needle and colored yarns. Unlike the float weave patterns of the Akwete woman's wrap shown on the preceding page, embroidery designs are not limited by the structure of the weave. The art of embroidery in West Africa is strongly associated with Islam, and the work on this garment may have been

done by Hausa men, noted embroiderers from northern Nigeria who follow the Islamic faith. A team of embroiderers may have worked for more than a month to complete these intricate designs.

❋ ❋ ❋ ❋ ❋ ❋ ❋ ❋ ❋ ❋ ❋ ❋ ❋ ❋ ❋ ❋ ❋ ❋

TITLE: Man's Robe
MATERIALS: cotton fibers
SIZE: 52 inches long (132 cm), 102 inches wide (259 cm)
DATE: early 20th century
CULTURE: Yoruba
LOCATION: Nigeria, Republic of Benin

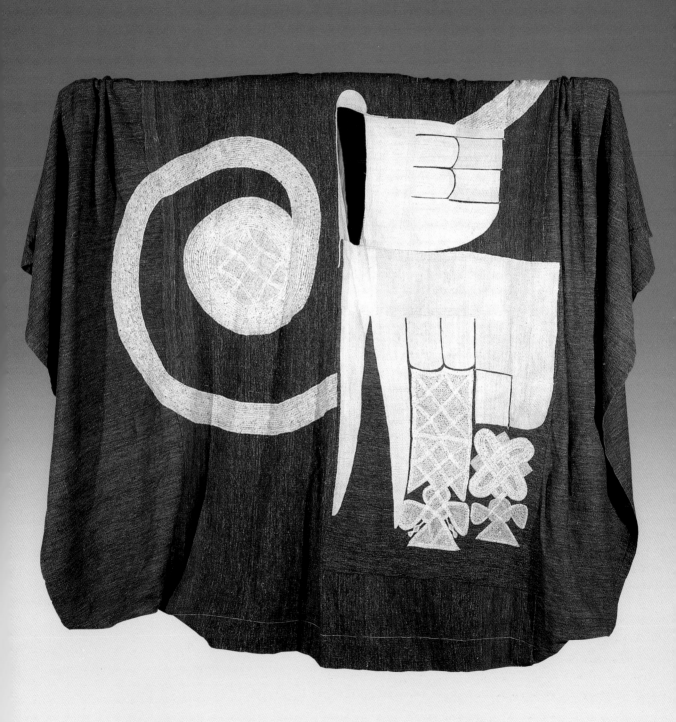

Rhythmic Cloth

Many narrow strips, with bars of contrasting colors, send pulsing rhythms across the whole cloth.

The use of a narrow-band loom to produce thin strips of cloth has a long history in West Africa. Fine examples with intricate designs that date back to the eleventh century have been found in cave burial sites in Mali. The refined quality of these very old works suggests an even earlier history of the development of narrow-loom textiles in West Africa. Their use in a burial tomb suggests that great importance was attached to them.

The thin strips of fabric produced on narrow looms often have stripes running the length of the cloth. These are called warp-faced cloths, because the colors of the long warp threads dominate. In this example, however, the stripes run across the narrow width of each strip. This type of cloth is known as weft-faced, since the cross stripes are made by using more weft threads and fewer warp threads.

The stripes across the cloth create a rhythmic effect that is intensified by the contrasting colors. Although the stripes may appear random, great care

TITLE: Strip Cloth Textile
MATERIALS: cotton
SIZE: 72 inches (2 yards) long (183 cm), 48 inches wide (122 cm)
DATE: early 20th century
CULTURE: unknown
LOCATION: West Africa, possibly Nigeria

has been taken in cutting the strips and sewing them together, to create a subtle zig-zag of the dark stripes across the full width of the assembled cloth.

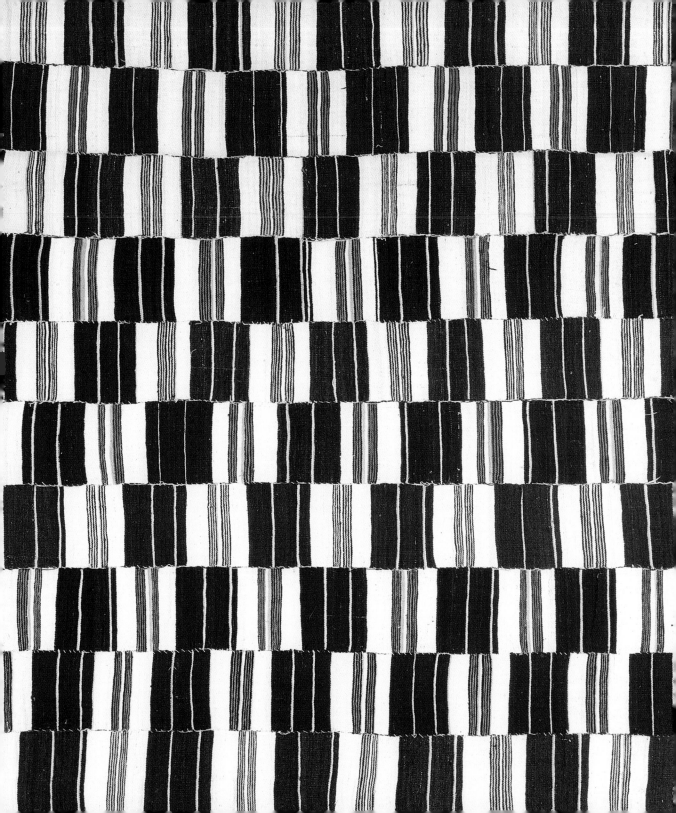

Extraordinary Creatures

Powerful Symbols from Great Animals

HORNBILL/LIZARD MASK, Bwa or Nuna culture

Eyes Filled with Inner Life

Lively designs and pointed, ring-like eyes express the inner spirit that the makers of this mask believe to exist in creatures of the bush.

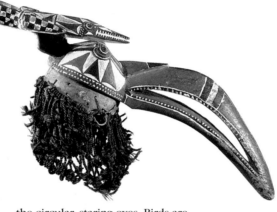

Africa's marvelous animals often trigger the creative imagination as a source of expressive and symbolic images.

Some animal images convey lessons from myth or concepts about the universe, such as the idea of division between the village—a safe, orderly place—and the bush—a dangerous, unpredictable place where troublesome spirits lurk. However, they recognize that the wilderness can enrich life, both through the mediators who are able to channel its forces and through medicines that are made from its wealth of plant and animal substances. Works of art dealing with this duality are ways of mediating with the wilderness. They express what is hidden and unpredictable, and they help to strengthen a shared understanding of the universe.

The people of several cultures in Burkina Faso are noted for their dramatic masks of bush spirits. In the complex mask illustrated here, the faces of the lizard and the hornbill have been superimposed, thus doubling the effect of the circular, staring eyes. Birds are often associated with the spirit-world as messengers, given their ability to navigate the skies.

✿ ✿ ✿ ✿ ✿ ✿ ✿ ✿ ✿ ✿ ✿ ✿ ✿ ✿ ✿ ✿ ✿ ✿ ✿

TITLE: Hornbill/Lizard Mask
MATERIALS: wood, pigment, fiber
SIZE: 61 ¹/₂ inches long (156.1 cm)
DATE: 19th-20th century

CULTURE: Bwa or Nuna
LOCATION: Burkina Faso

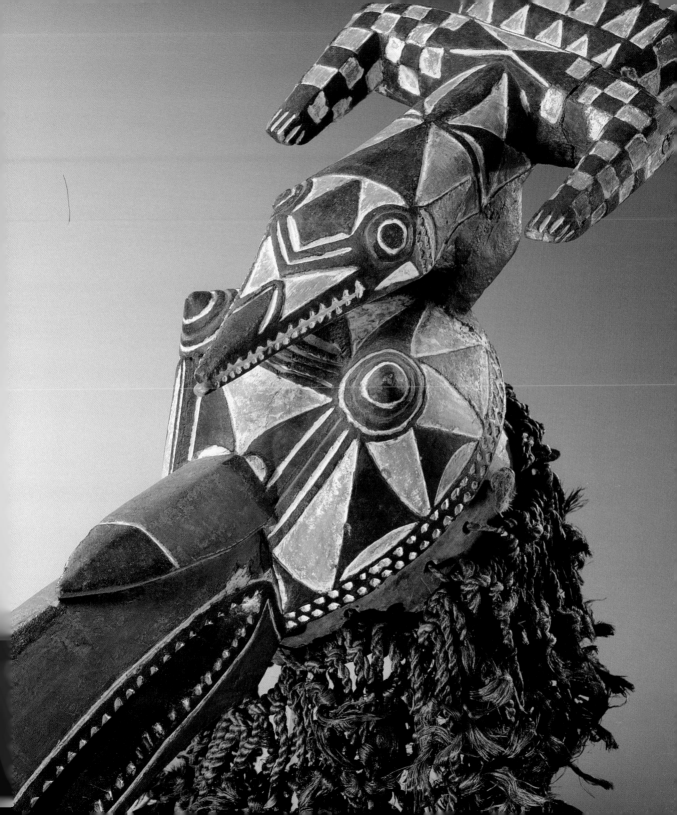

CHI WARA HEADDRESS, Bamana culture

Mythological Spirit of Farming

Like crops shooting forth from the furrowed earth, the tall horns springing from the ground-hugging body of this mythical creature suggest the bounty of a successful season.

The life-sustaining labor of farming is especially precious for people who live along the southern reaches of the Sahara Desert. In the *Chi Wara* society of the Bamana culture, the elders teach young farmers and preserve the collective knowledge of agricultural practices. Pride in their work is heightened through performances involving a pair of dramatic headdresses, like this striking example. Champion farmers are selected to dance the *Chi Wara* headdresses at planting time, again at harvest, and for purposes of instruction.

Women sing praises to the ideal farmer and dance along with the champions. In daily life, women help with farming chores and sustain the men with food the and drink that they bring to the fields.

Further expressing the unity of men and women, *Chi Wara* headdresses are fashioned in male and female versions. Shown here is a male headdress. Its head, neck, and horns are those of a roan antelope, while the squat, lower part of the body and legs represents a

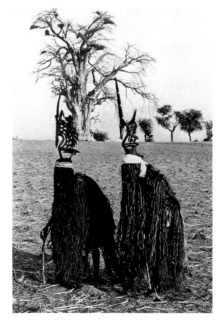

type of anteater, the aardvark. To wear it, the dancer ties it to a cap by means of holes drilled in the figure's base.

This *Chi Wara* headdress illustrates how African artists clothe invisible ideas and forces with visible form, creating magical works of art that convey messages and inspire the spirit. The symbolic language of the *Chi Wara*

headdress includes large, vertical horns, resembling the growth of millet. Additional, smaller horns endow this work with extra power. Angular patterns in the neck represents the zigzag path of the sun between the solstices as well as the zigzag path the antelope takes as it runs. Cultivation is symbolized by the burrowing of the aardvark, while planting is signified by the male penis. To complete the cycle from planting to harvest, rain is represented by long fibrous strands that hang from the headdress and cover the dancer (see illustration).

TITLE: Chi Wara Headdress
MATERIALS: wood
SIZE: 34 inches high (86.4 cm)
DATE: 19th-20th century

CULTURE: Bamana
LOCATION: Mali

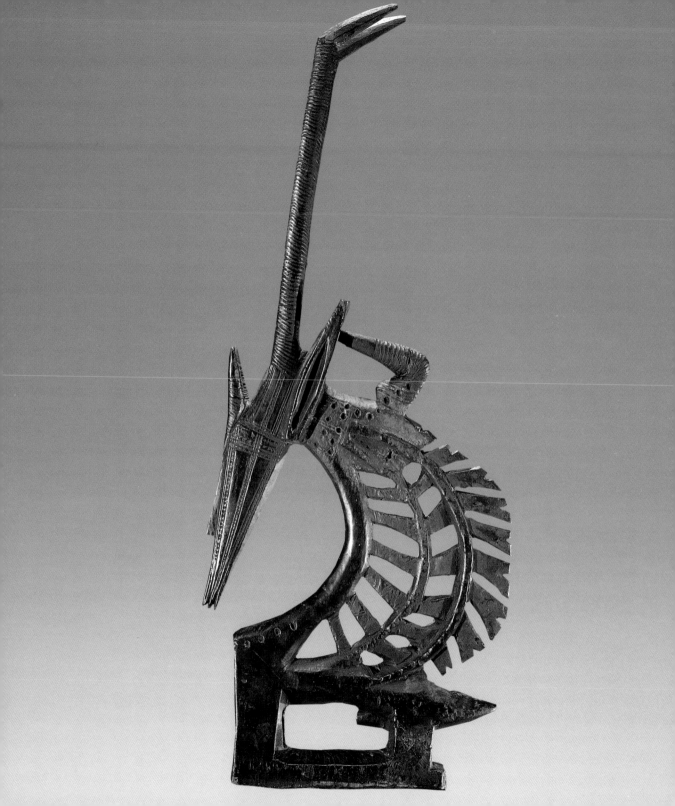

BUFFALO MASK AND FEATHER COSTUME, possibly Bamum culture

Guardian of Social Customs

This impressive mask was owned by a member of a special society that had royal authority to uphold the laws and values of the realm.

Among the kingdoms of the Grasslands region of Cameroon, large, dramatic masks are owned by men of the high-ranking *Kwifoyns*. These are societies responsible for enforcing the laws and upholding social values and mores among people of their communities. The masks represent human heads, birds, buffalo, or elephants, and they appear together in groups. One or more of them, outfitted with a special feather cape, announces the coming of the *Kwifoyn*, proclaiming its decrees in the marketplace and demanding appropriate behavior. The other masks of the group have fabric garments.

This stunning representation of a buffalo commands respect from all who see it. Its watchful eyes, perked ears, flaring nostrils, and bared teeth show that all its senses are alert. The buffalo head, combined with the feather-covered cape, remind us that a mask is more than a covering for the face. It is an assemblage of elements that attains greater meaning as an ensemble. Here, the buffalo refers to royal power, the

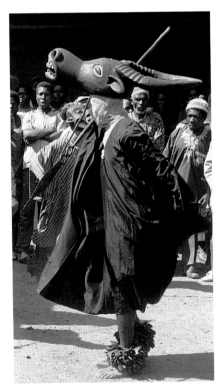

the people of the Cameroon Grasslands, the buffalo is a royal symbol, and only a king can grant the privilege of owning a mask or other image of this mighty animal. When the mask is danced in celebrations, either to praise the king, to give thanks for the harvest, or to commemorate the dead, the rustling movement of the feathers adds to the drama of the performance.

TITLE: Buffalo Mask and Feather Costume
MATERIALS: wood, feathers, burlap, string
SIZE: approx. 72 inches high overall (183 cm)
DATE: 19th-20th century

CULTURE: possibly Bamum
LOCATION: Cameroon

feather cloak to its role as messenger. The African buffalo is an intelligent and powerful animal. Though generally peaceful, it becomes ferocious and is greatly feared if it is disturbed. Among

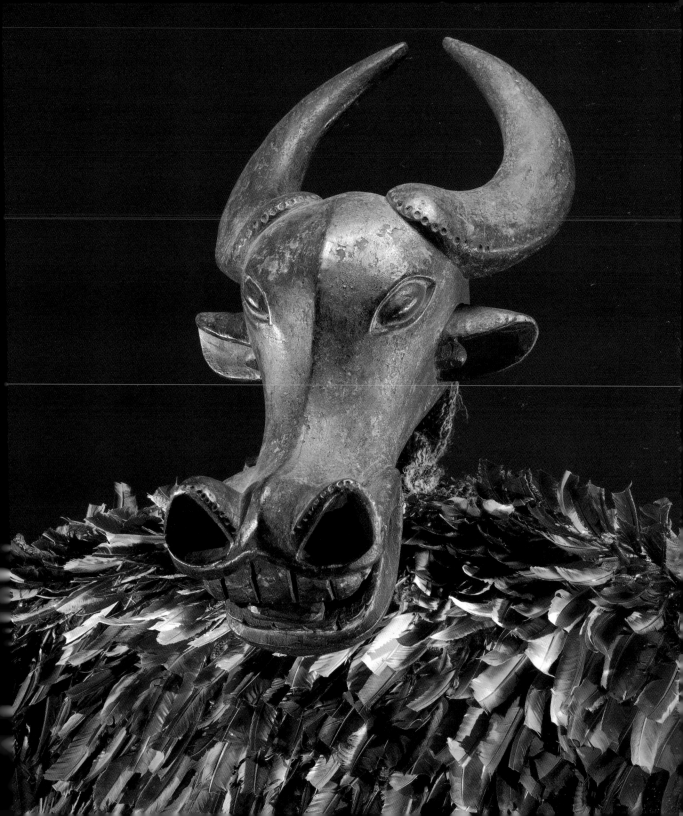

Homely Symbol of an Invisible Spirit

To ward off evil spirits or to determine the cause of misfortune in the community, sacrifices are poured over the statue of a monkey.

Baule artists are noted for producing finely detailed, highly polished sculptures that show a great love of beauty (see Heddle Pulley, page 48). For a spirit to inhabit a statue or a mask, the Baule believe the work must be pleasing in appearance.

Contrasting with such beauty, the blocky forms of this monkey statue are rudely carved. In part, this is because it was made by a blacksmith rather than a trained carver. But there is another reason for its crudeness. The Baule think a statue should be ugly when it symbolizes an invisible spirit that does not dwell in the object itself, and the crude appearance of the monkey-statue is also suited to its intended role: to fend off evil spirits. Through their rituals, members of a divination cult activate the unseen powers behind images like this.

An egg, symbol of primordial life and source of future prosperity, would have been held in the monkey's cupped hands. From rituals meant to tap the powers of the spirit-world, numerous sacrifices of animal blood have formed a crusty residue on the surface of the figure, especially on the head and the shoulders, where the vestiges of several feathers also remain.

TITLE: Monkey Figure
MATERIALS: wood, iron, cloth, miscellaneous accretions
SIZE: 22 1/4 inches high (56.5 cm)
DATE: 19th-20th century

CULTURE: Baule
LOCATION: Ivory Coast

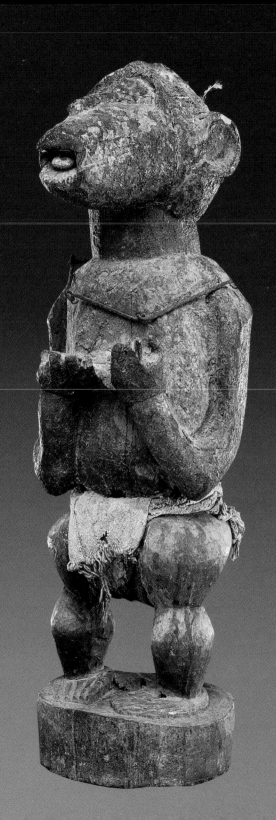

STATUE OF A BIRD, Senufo culture

Symbol of Community

Standing proudly, this image of a great bird signifies lessons about the ancestors, social customs, and future generations.

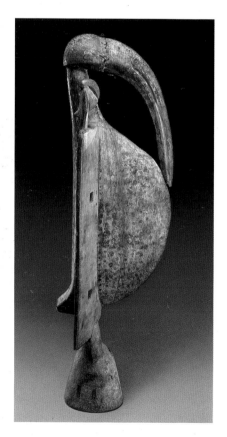

This great bird, standing more than four feet tall, symbolizes the beliefs of the Senufo people regarding ancestry and community. According to Senufo myth, the bird and four other primordial animals, the snake, turtle, crocodile, and chameleon, were present with the first man and the first woman. Sometimes the bird itself is called "the first ancestor." Perched on its spreading, wing-like flanks, two young birds introduce the theme of new generations.

A sacred grove is an important area where ritual events take place in a Senufo village. In some villages, the great statue of the bird may be seen there, standing on the earth.

The statue also plays a role in *poro,* an important male social institution that concerns itself with ancestors, family, and village unity. In this context, the bird is known as "mother of the *poro* child," associating it with the elders, or "mothers," who act as guardians of the young initiates. Adding to this maternal reference, the sculpture's swollen abdomen alludes to pregnancy.

A slight hollow under the statue's base makes it easier for a *poro* initiate to display his strength and leadership by hoisting the heavy statue aloft and carrying it on his head in an initiation procession.

TITLE: Hornbill Statue/Headdress
MATERIALS: wood, paint, iron
SIZE: 52 ¼ inches high (132.7 cm)
DATE: 19th-20th century

CULTURE: Senufo
LOCATION: Ivory Coast

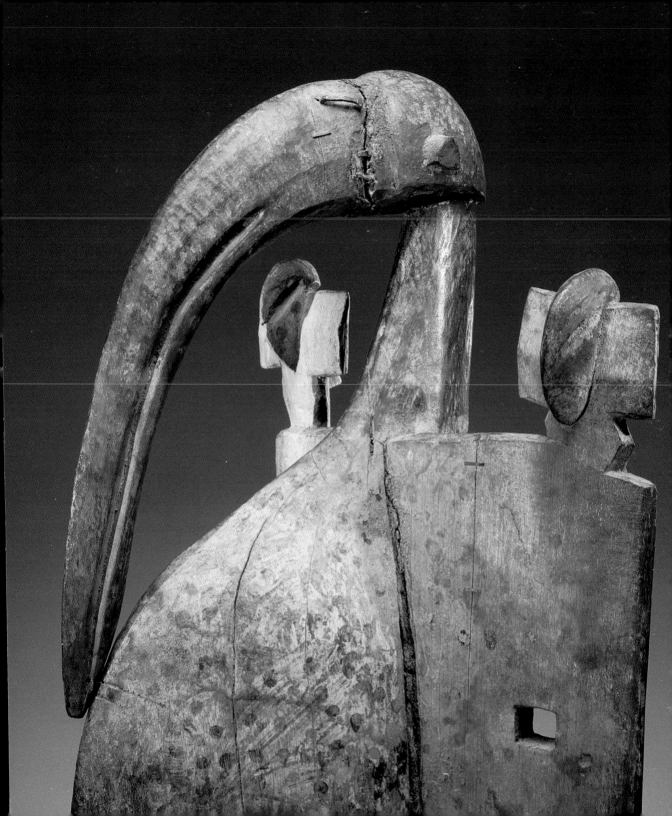

Masks

❖❖❖❖❖❖❖❖❖❖❖❖❖❖❖❖❖❖❖❖❖❖❖❖❖❖❖❖❖❖❖❖❖❖❖❖

Presence of the Spirit World

From Face Alone to Complete Persona

Although African masks can be appreciated purely aesthetically, their primary role is to reinforce social codes and beliefs through contact between humans and the spirit-world.

Masks are one of the most widespread art forms in Africa. Whether their features are human, animal, or imaginary, African masks invoke mystery and stir the spirit in ways unequaled by other forms of art. But their strangeness can make them hard to understand, and because we are more used to seeing masks as a form of entertainment, their social meaning and deep spiritual power can be difficult for us to fathom.

The masks shown on this and the following two pages are from the Dan culture, from the northwestern area of the Ivory Coast and nearby, in Liberia. The mask shown on the facing page is actually a fragment of a mask. Other elements, now missing, were once fastened to it through the holes around its edges. The mask on the next page is similar, but has a braided coiffure—a partial mask assemblage. The third mask is complete, being fully embellished with many attachments. The entire assemblage is important to the meaning of this mask, known as *Ga Wree-Wre,* a judgment spirit. A band

of white pigment has been applied across its thin, slit eyes as a sign of purity and beauty. It wears an elaborate headdress of cowrie shells and beads and a cone-shaped hat (not visible in photograph). Glass beads, brass bells, and many brass leopard's teeth are strung along the chin, and a cape of striped fabric attached to the mask would fall to the wearer's waist, to cover the top edge of a voluminous raffia skirt.

This solemn mask combines signs of the forest wilderness (raffia skirt) and power over animals (leopard's teeth) with the elegance and technology human civilization (slit eyes and white pigment, textile cape, and elaborate headdress). When it makes one of its rare appearances in the village, *Ga-Wree-Wre's* authority in judging important disputes is heightened by the dancer's slow and dignified movements. In fact, the mask is not danced, but rather walks deliberately and sits. The mask delivers judgments through a human speaker, who stands next to the mask as it hears a dispute.

TITLE: Mask
MATERIALS: wood
SIZE: 8 inches high (20.3 cm)

OVERLEAF:

TITLE: Mask with Braided Coiffure
MATERIALS: wood, fiber
SIZE: 22 inches high (55.9 cm)

TITLE: *Ga Wree-Wre* Mask
MATERIALS: wood, metal, fiber, cowrie shells, glass beads, brass, bone, handwoven cloth
SIZE: 47 inches high (119 cm) including cape

DATE: 19th-20th century
CULTURE: Dan
LOCATION: Liberia, Ivory Coast

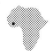

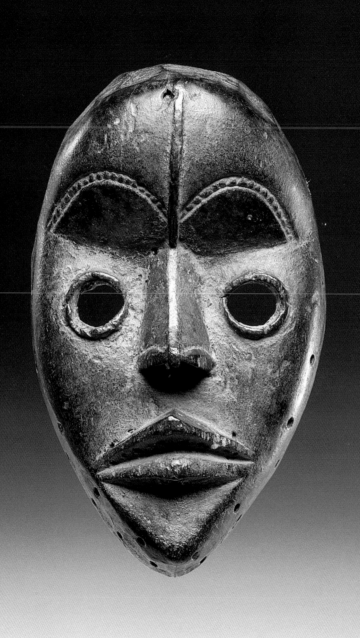

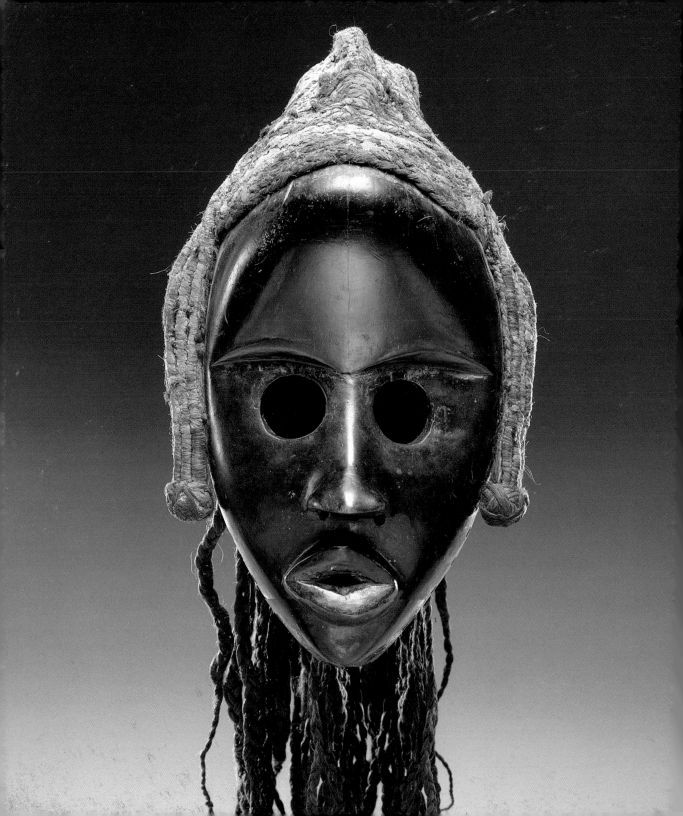

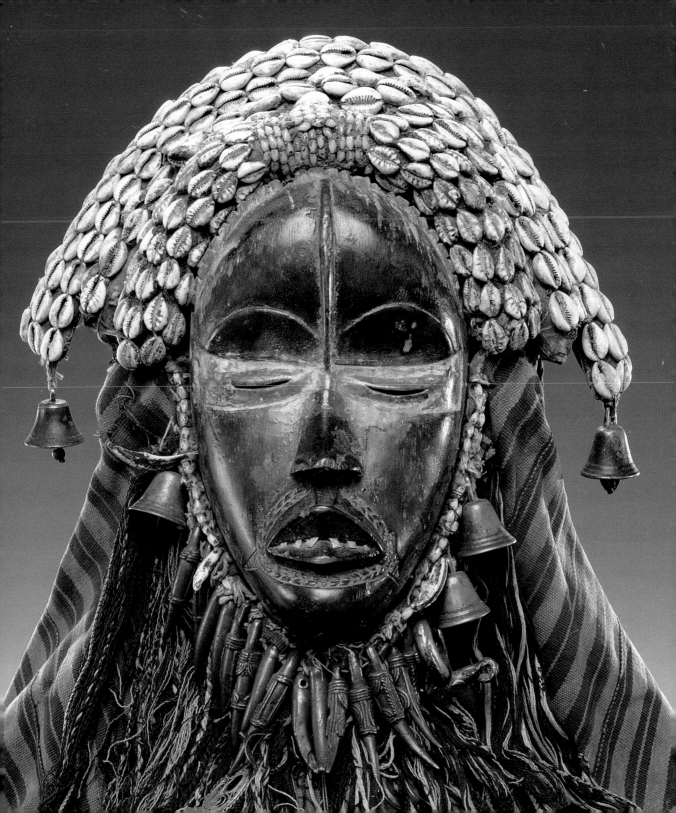

A Portion of a Mask

The full drama of a mask includes an entire costume and, even more importantly, a human setting with music, dance, and song.

The face, horns, mouth, and "legs" projecting from the edges of this mask have been skillfully cast as one piece of metal. Other parts of the mask were cast separately: the chin or beard, three flanges on either side of the face, and the eyebrow/nose unit. Two tabs on the forehead once fastened yet another part, perhaps a comb, a bird, or some other form that has significance for the people who originally owned the mask.

A mask such as this raises questions of identification, interpretation, and use of masks—among the Senufo as well as other African cultures. Whether the mask has been made of metal or wood, Senufo villagers view this type of mask as female. The upraised horns represent an antelope, and the eyebrow and nose unit strongly resembles the horns and head of a ram, a sacrificial animal.

The Senufo say that the flanges and "legs" jutting from the sides of the face are decorative rather than symbolic. Yet this type of mask has been made for several centuries and it probably originated among the people of another culture, the Diula. Because the Senufo adopted this mask type from others, and because there have been changes among the Senufo themselves over many generations, these shield-like shapes may have lost their original meaning.

Further obscuring identification of this mask is the absence of the rest of the costume that would have been worn with it, for the face alone does not define its character. This mask can represent either of two characters, determined by its outfit and what it holds in its hands.

❀ ❀ ❀ ❀ ❀ ❀ ❀ ❀ ❀ ❀ ❀ ❀ ❀ ❀ ❀ ❀ ❀

TITLE: Mask
MATERIALS: brass
SIZE: 11 inches high (27.9 cm)
DATE: 19th-20th century

CULTURE: Senufo
LOCATION: Ivory Coast

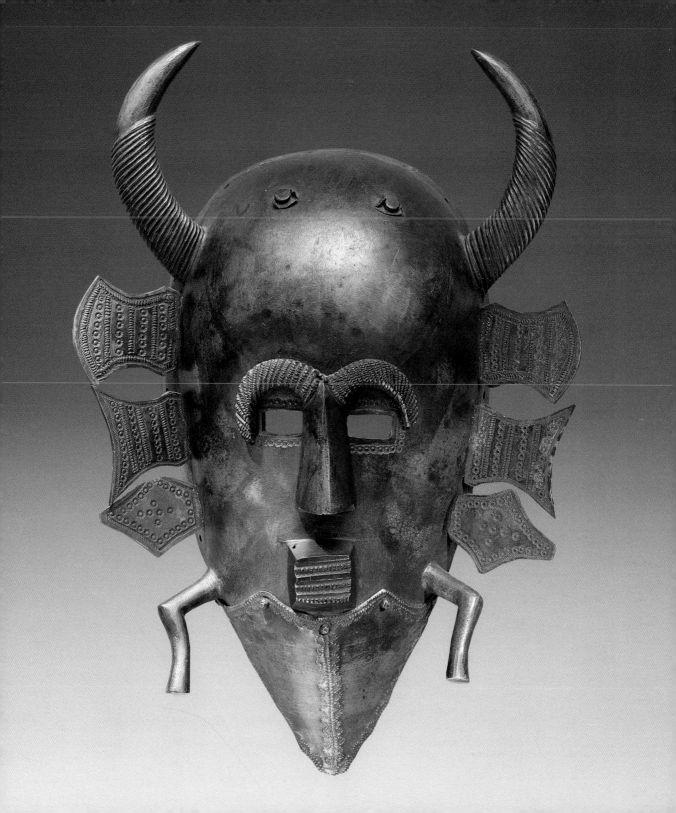

A Secret Language of Signs and Charms

Coded messages and magical charms endow this rare mask with mysterious powers.

The delicate features of this face, its slender nose, and gently rounded eyes, are nearly hidden beneath layers of paint, white clay, copper, and brass tacks. Surrounding the head and further hiding the face are layers of feathers, fur, and seeds, attached to matted clumps of grass or raffia.

Typically the use of a mask is prescribed by priests, elders, or others of higher rank. In this way, masks support the structures of belief and authority in a community. Some of these beliefs are known by everyone in the community, while others are governed by secrets known only to a few.

This extraordinary mask comes from the people of a little-known culture, the Dinga. Their masks are very rare and probably belonged to members of a men's society. The numerous charms and talismans attached to the head-covering—feathers, pelts, beetle horns, seed pods, and the dramatic talons of a bird of prey (illustrated at left)—declare the owner's belief in supernatural forces. Likewise, the painted markings and attachments on the face are part of a language of symbols that would have been known by the mask's owners.

The well-worn surface of the wood, the layers of pigment on the face, and the use of charms in the head-covering, all illustrate how a mask can "live" for years, even generations, acquiring more meaning and status with age. The fact that a mask is retained, repaired, and embellished repeatedly shows that it is held in high esteem.

* * * * * * * * * * * * * * * * * * * *

TITLE: Mask
MATERIALS: wood, copper, brass tacks, fiber, raffia cloth, glass beads, feathers, other natural materials
SIZE: 20 1/2 inches high (52 cm)
DATE: 19th-20th century

CULTURE: Dinga
LOCATION: Zaire, Angola

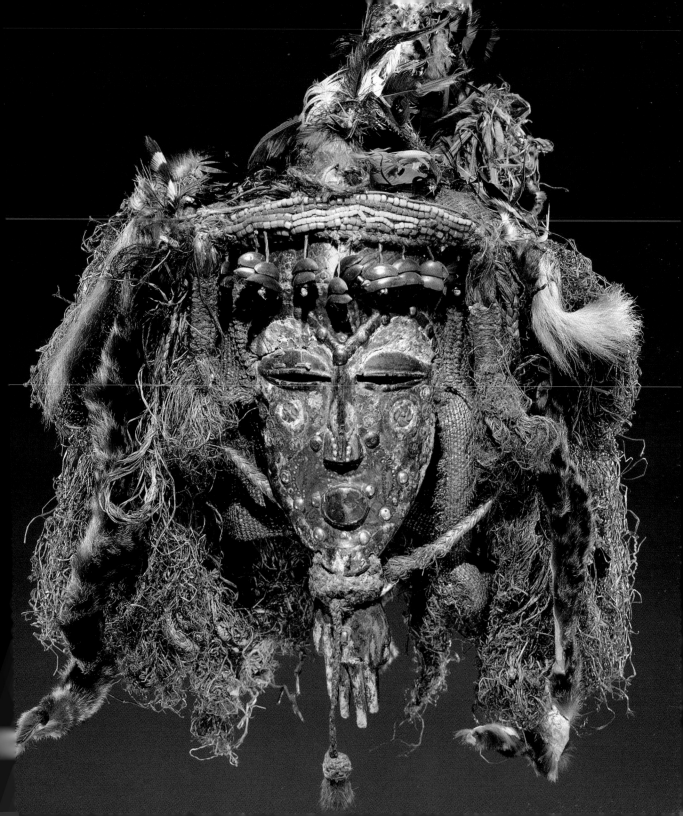

"To Climb The Slopes of The Sky" — Lega saying

Lega artworks are used to teach moral values and serve as symbols of their owner's knowledge.

Unlike the elaborate and showy Dinga mask, Lega masks are the essence of simplicity and restraint. Their mystery and quiet charm comes from their muted, almost ghostly appearance, which is further enhanced by the white clay applied to the face of the two wooden masks shown here (near right and opposite page).

Small wooden masks with beards, such as the one shown here, are the most common of the five types of *Bwami* masks, while small bone or ivory masks are reserved for initiates of the highest *Bwami* grade, the *Kindi*. The large wooden masks (see color photo) are owned by the very highest grade of *Kindi,* the preceptors. The masks may be displayed on racks, held in the hands, or worn on the arm or on the head in *Bwami* ceremonies.

All three masks are part of an array of emblems that indicate rank in the Lega's *Bwami* association, the all-encompassing social organization that governs Lega customs and mores (see pages 40 and 41).

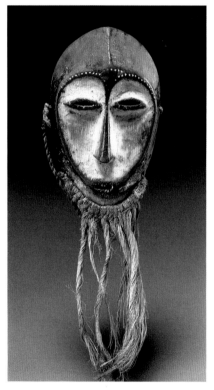

TITLE: Bwami Mask
MATERIALS: wood, white clay, fiber
SIZE: 11 inches high (27.9 cm)
DATE: 19th-20th century

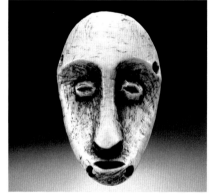

TITLE: Bwami Mask
MATERIALS: ivory
SIZE: 3 1/8 inches high (7.9 cm)
DATE: 19th-20th century

TITLE: Bwami Mask
MATERIALS: wood, white clay
SIZE: 10 inches high (25.4 cm)
DATE: 19th century

CULTURE: Lega
LOCATION: Zaire

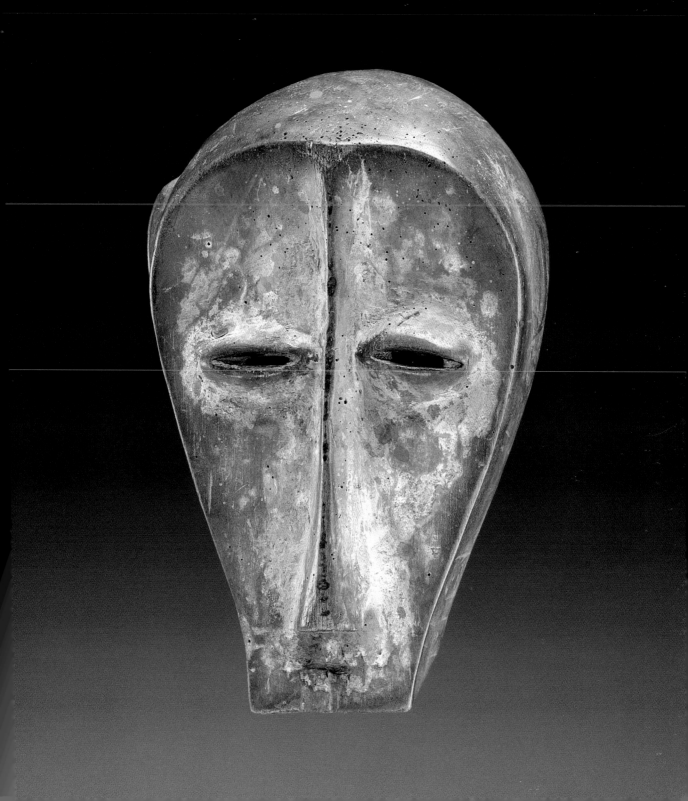

Dazzling Masks that Link History and Statecraft

This trio of Kuba royalty masks affirm the authority of the king and his descent from the legendary founder of the royal lineage.

These three spectacular masks relate to Kuba statesmanship and mythology. There are many stories about their origin, their identity, and their meaning. Generally speaking, the elegant *Ngady amwaash* mask (illustrated in color) represents *Mweel,* sister of *Woot,* the legendary founder of the Kuba. She also personifies a beautiful woman desired by the two males, represented by the other two masks of the ensemble.

The *Mukenga* mask (near right) is a regional variation of the royal mask representing the king of the Bushoong people, the ruling ethnic group in the Kuba kingdom. The elephant trunk rising from his head proclaims his greatness. Both the *Ngady amwaash* and *Mukenga* masks dance with great dignity and pride.

The third mask, *Bwoom,* is said to represent the king's brother and stands for the common man. *Bwoom* loves to posture before *Ngady amwaash* and the audience. Together, these three masks remind the Kuba of their legendary history and royal lineage.

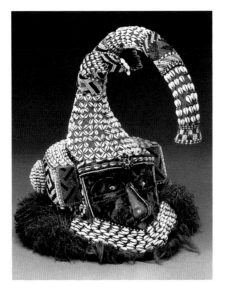

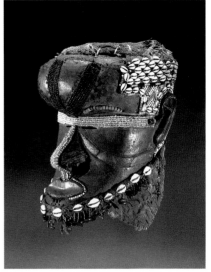

* *

TITLE: *Mukenga* Mask
MATERIALS: raffia cloth, leopard skin, wood, cowrie shells, glass beads, string
SIZE: 19 1/2 inches high (49.5 cm)

* *

DATE: 19th-20th century
CULTURE: Kuba
LOCATION: Zaire

* *

TITLE: *Bwoom* Mask
MATERIALS: wood, copper, cloth, glass beads, cowrie shells, seeds, string, traces of paint
SIZE: 19 1/4 inches high (48.9 cm)

* *

TITLE: *Ngady amwaash* Mask
MATERIALS: wood, paint, glass beads, cloth, cowrie shells, string, raffia cloth
SIZE: 12 1/2 inches high (31.8 cm)

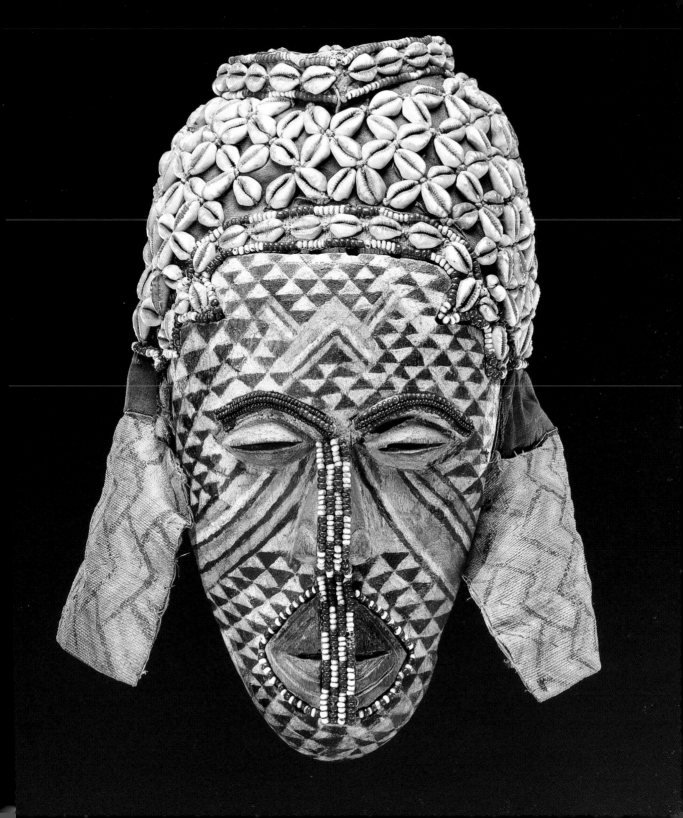

EGUNGUN MASK, Yoruba culture

Ancestral Visage That Whirls Through The Community

Egungun masks express the close relationship between the world of the living and the spirit of the ancestors.

Festivals honoring the ancestors and celebrating the bonds between the living and the dead are important events in many African societies. To prepare for such events the Yoruba assemble spectacular body-length masks made from layer upon layer of brightly patterned cloth. These dramatic masks, known as *Egungun,* appear at Yoruba festivals in honor of the ancestors. The brilliant fabric cascade conceals the dancer, who peers out through a mesh panel in front of his face, near the center of the mask. As he spins in dance, the strips of fabric fly out, as if in a whirlwind, evoking the return of ancestral spirits to the world of the living.

Egungun festivals, which take place yearly or every other year in a Yoruba community, involve several weeks of family rituals and public celebrations. Performances of the masks, which are owned by individual families, are held at the forest of *Egungun,* in the marketplace, and in front of the palace. The powers of the ancestors may also be called upon through *Egungun* perfor-

mances in moments of crisis for a family or a community, such as the death of a family member or widespread pestilence. The artistry involved in dancing the *Egungun* is rich and complex, and styles and performances vary from region to region.

The construction of an *Egungun* mask itself links generations symbolically. In the example shown here, older, hand-woven cloth has been covered by layers of newer, machine-made cloth:

the fabric of the ancestors is physically connected to the cloth of today, through the spirit of *Egungun.* All of the strips of cloth hang from a flat board that the dancer balances on his head. This board gives the mask its rectangular, unearthly form. Shiny bits of metal attached to the mask and jagged edges stitched to each of the hundreds of cloth strips further enliven the colorful ensemble in its whirling dance.

❋ ❋ ❋ ❋ ❋ ❋ ❋ ❋ ❋ ❋ ❋ ❋ ❋ ❋ ❋ ❋ ❋

TITLE: Egungun Mask
MATERIALS: cloth, wood, metal
SIZE: 63 inches high (160 cm)
DATE: 20th century

CULTURE: Yoruba
LOCATION: Nigeria, Republic of Benin

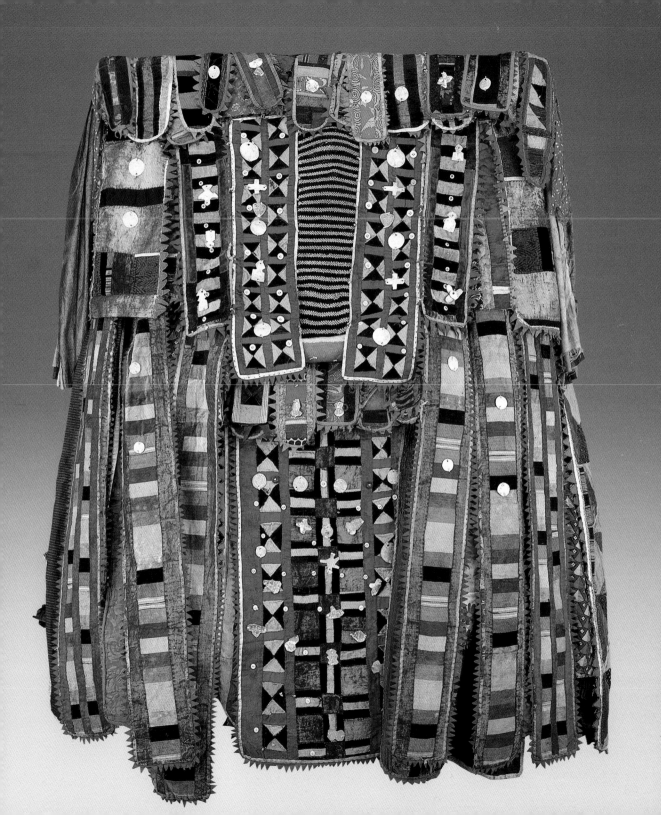

Credits

OBJECT CREDITS

All of the objects featured in this book are in the collection of the Virginia Museum of Fine Arts, Richmond, Virginia, U.S.A. Objects of this quality could only be acquired through the generosity of insightful donors whose gifts, bequests, and financial contributions made this collection possible and will ensure its continuing development in the future. On the list that follows, their names appear with the appropriate objects.

PHOTOGRAPHY CREDITS

Except as noted in the following list, all objects were photographed especially for this book by Katherine Wetzel, Richmond, Virginia.

FRONT COVER & FRONTISPIECE

Kneeling Female Figure, Hemba culture, Acc. No. 77.92
Virginia Museum of Fine Arts Purchase, The Adolph D. and Wilkins C. Williams Fund

CHAPTER 1

Memorial Portrait Head, Akan culture, Acc. No. 88.42
Virginia Museum of Fine Arts Purchase, The Arthur and Margaret Glasgow Fund

Mother and Child, Kongo culture, Acc. No. 87.84
Virginia Museum of Fine Arts Purchase, The Adolph D. and Wilkins C. Williams Fund

Standing Female Figure, Akan culture, Acc. No. 94.3
Virginia Museum of Fine Arts Purchase, The Adolph D. and Wilkins C. Williams Fund

Plaque of a Chief, Benin culture, Acc. No. 83.136
Virginia Museum of Fine Arts Purchase, The Adolph D. and Wilkins C. Williams Fund

Community Power Figure, Songye culture, Acc. No. 89.27
Virginia Museum of Fine Arts Purchase, The Adolph D. and Wilkins C. Williams Fund

Kneeling Male Figure, unidentified culture, Djenne region, Acc. No. 80.169
Virginia Museum of Fine Arts Purchase, The Adolph D. and Wilkins C. Williams Fund

CHAPTER 2

Scepter, Kongo culture, Acc. No. 85.591
Virginia Museum of Fine Arts Purchase, The Adolph D. and Wilkins C. Williams Fund

Eshu Staff, Yoruba culture, Acc. No. 88.43
Virginia Museum of Fine Arts Purchase, The Adolph D. and Wilkins C. Williams Fund

Ifa Diviner's Box, Yoruba, Acc. No. 77.94
Virginia Museum of Fine Arts Purchase, The Adolph D. and Wilkins C. Williams Fund

Kneeling Woman Holding a Bowl, Luba culture, Acc. No. 93.50a
Virginia Museum of Fine Arts Purchase, The Adolph D. and Wilkins C. Williams Fund

Royal Stool, Luba culture, Acc. No. 91.502
Virginia Museum of Fine Arts Purchase, The Arthur and Margaret Glasgow Fund

Trumpet, Mende culture, Acc. No. 79.143
Virginia Museum of Fine Arts Purchase, The Kathleen Boone Samuels Memorial Fund

Royal Linguist's Staff, Akan culture, Acc. No. 86.200a/c
Virginia Museum of Fine Arts Purchase, The Kathleen Boone Samuels Memorial Fund

Necklace, Akan culture, Acc. No. 80.73
Virginia Museum of Fine Arts Purchase, The Adolph D. and Wilkins C. Williams Fund

Beaded Crown, Yoruba, Acc. No. 92.150
Virginia Museum of Fine Arts Purchase, The Kathleen Boone Samuels Memorial Fund
Photograph of the Orangun-Ila (King of Ila) wearing the great beaded crown known as "Ologun," (Warrior), taken in Nigeria, 1984, by John Pemberton III.

Man's Bwami Hat, Acc. No. 88.123
Woman's Bwami Hat, Acc. No. 88.119
Man's Bwami Hat, Acc. No. 88.125
Virginia Museum of Fine Arts Purchase, The Adolph D. and Wilkins C. Williams Fund

CHAPTER 3

Necklace, Acc. No. 92.183
Necklace, Acc. No. 92.33
Bracelet, Acc. No. 92.24
Figurines, Acc. Nos. 92.56, .57, .58
Pendant, Acc. No. 92.36
Gifts of Mr. and Mrs. Philip M. Nesmith in Memory of Fisher H. Nesmith, Jr.

Earrings, Fulani culture, Acc. No. 80.74.1/2
Virginia Museum of Fine Arts Purchase, The Adolph D. and Wilkins C. Williams Fund
Photograph of Fulani woman in Mopti, Mali,

by Eliot Elisofon, 1970. Courtesy of the National Museum of African Art, Eliot Elisofon Photographic Archives, Smithsonian Institution, Washington, D.C.

Heddle Pulley in Form of Mask, Baule culture, Acc. No. 93.6
Virginia Museum of Fine Arts Purchase, The Adolph D. and Wilkins C. Williams Fund

Snuff Container, Zulu culture, Acc. No. 93.5
Gift of Mr. and Mrs. Marc Ginzberg

Headrest, Shona culture, Acc. No. 85.1542
Gift of Robert and Nancy Nooter
Photograph of a Wanoe Shona man sleeping on a headrest, 1928. Courtesy Peter Steigerwald, Frobenius-Institut, University of Frankfurt.

Woman's Wrap Skirt, Kuba culture, Acc. No. 85.592
Virginia Museum of Fine Arts Purchase, The Kathleen Boone Samuels Memorial Fund

Woman's Wrap Skirt and Shawl, Igbo culture, Acc. No. 77.123 a,b
Gift of A. Thompson Ellwanger, in memory of Dr. and Mrs. George W. Sadler and Henrietta Sadler Kinman
Photograph of a young woman from Finima, Nigeria, going through her coming-of-age ceremony, in which she wears various imported cloths, including this one from the Akwete Igbo area. Photo courtesy of Lisa Aronson, 1990.

Man's Robe, Yoruba culture, Acc. No. 79.127a
Gift of Mr. and Mrs. George W. Sadler, in memory of Dr. and Mrs. George W. Sadler and Henrietta Sadler Kinman
Photograph of two chiefs wearing their *agbadas* voluminous robes embroidered with silk designs, at the Festival for the Oba in Ila-Orangun, Nigeria, 1984, by John Pemberton III.

Strip Cloth Textile, unknown culture, Acc. No. 77.113
Gift of A. Thompson Ellwanger, in memory of Dr. and Mrs. George W. Sadler and Henrietta Sadler Kinman
Photograph of strip-loom courtesy of the author.

CHAPTER 4

Hornbill/Lizard Mask, Bwa or Nuna culture, Acc. No. 79.144
Virginia Museum of Fine Arts Purchase, The Kathleen Boone Samuels Memorial Fund

Chi Wara Headdress, Bamana culture, Acc. No. 77.93
Virginia Museum of Fine Arts Purchase, The Adolph D. and Wilkins C. Williams Fund
Photograph of Bamana Chi-Wara headdress dancers near Bamako, Mali, by Eliot Elisofon, 1971. Courtesy of the National Museum of African Art, Eliot Elisofon Photographic Archives, Smithsonian Institution, Washington, D.C.

Buffalo Mask and Feather Costume, possibly Bamum culture, Acc. No. 87.464 a/b
Virginia Museum of Fine Arts Purchase, The Arthur and Margaret Glasgow Fund
Photograph of buffalo masks dancing at a commemorative death celebration in the Kingdom of Oku in 1976, by Tamara Northern.

Monkey Figure, Baule culture, Acc. No. 82.117
Gift of Dr. and Mrs. Hilbert H. DeLawter

Statue of a Bird, Senufo culture, Acc. No. 85.1541
Gift of Robert and Nancy Nooter

CHAPTER 5

Mask, Acc. No. 87.449
Gift of Robert and Nancy Nooter

Mask with Braided Coiffure, Acc. No. 77.95
Virginia Museum of Fine Arts Purchase, The Adolph D. and Wilkins C. Williams Fund

Ga-Wree-Wre Mask, Acc. No. 92.242
Virginia Museum of Fine Arts Purchase, The Adolph D. and Wilkins C. Williams Fund

Mask, Senufo culture, Acc. No. 84.108
Gift of Beatrice Riese

Mask, Dinga culture, Acc. No. 90.154
Virginia Museum of Fine Arts Purchase, The Adolph D. and Wilkins C. Williams Fund

Bwami Mask, Acc. No. 77.84
Virginia Museum of Fine Arts Purchase, The Adolph D. and Wilkins C. Williams Fund

Bwami Mask, Acc. No. 91.494
Gift of Beatrice Riese

Bwami Mask, Acc. No. 87.462
Virginia Museum of Fine Arts Purchase, The Arthur and Margaret Glasgow Fund

Mukenga Mask, Kuba culture, Acc. No. 87.82
Virginia Museum of Fine Arts Purchase, The Arthur and Margaret Glasgow Fund

Bwoom Mask, Kuba culture, Acc. No. 77.13
Virginia Museum of Fine Arts Purchase, The Adolph D. and Wilkins C. Williams Fund

Ngady amwaash Mask, Kuba culture, Acc. No. 87.83
Virginia Museum of Fine Arts Purchase, The Arthur and Margaret Glasgow Fund

Egungun Mask, Yoruba culture, Acc. No. 92.133
Gift of Dr. and Mrs. Jeffrey Hammer
Photograph of an *Egungun* costume being danced, courtesy of Robert Farris Thompson from African Art in Motion, Berkeley and Los Angeles: University of California Press, 1974.

Index

Suggested Reading List

GENERAL

Bascom, William. *African Art in Cultural Perspective*. New York: Norton, 1973.

Davidson, Basil. *Africa in History*. New York: Macmillan, 1991.

Murray, Jocelyn, ed. *Cultural Atlas of Africa*. New York: Facts on File, Inc., 1989.

Oliver, Roland, and J. D. Fage. *A Short History of Africa*. London: Penguin Books, 1990.

Sieber, Roy, and Roslyn Adele Walker. *African Art in the Cycle of Life*. Washington, D.C.: Smithsonian Institution Press, 1987.

Willett, Frank. *African Art: An Introduction*. New York: Praeger, 1993.

CULTURAL STUDIES

Cole, Herbert M., and Doran H. Ross. *The Arts of Ghana*. Los Angeles: Museum of Cultural History, University of California at Los Angeles, 1977.

Drewal, Henry John, and John Pemberton, with Rowland Abiodun. Yoruba: *Nine Centuries of African Art and Thought*. New York: The Center for African Art, 1989.

Eyo, Ekpo, and Frank Willett. *Treasures of Ancient Nigeria*. New York: Alfred A. Knopf, 1980.

Neyt, Francois. *Traditional Arts and History of Zaire: Forest Cultures and Kingdoms of the Savannah*. Louvain, Belgium: Institut Superieur d'Archeologie et d'Histoire de l'Art, 1981.

Northern, Tamara. *The Art of Cameroon*. Washington, D.C.: Smithsonian Institution Press, 1984.

AESTHETICS & PHILOSOPHY

Anderson, Martha G., and Christine Mullen Kreamer. *Wild Spirits Strong Medicine: African Art and the Wilderness*. New York: The Center for African Art, 1989.

Cole, Herbert M. *Icons: Ideal and Power in the Art of Africa*. Washington, D.C.: Smithsonian Institution Press, 1989.

Preston, George Nelson. *Sets, Series & Ensembles in African Art*. New York: The Center for African Art, 1985.

Thompson, Robert Farris. *Flash of the Spirit: African & Afro-American Art & Philosophy*. New York: Vintage Books, 1984.

TEXTILES & DECORATIVE ARTS

Picton, John, and John Mack. *African Textiles*. New York: Harper & Row, 1989.

Sieber, Roy. *African Furniture & Household Objects*. Bloomington: Indiana University Press in association with The American Federation of Arts, 1980.

——. *African Textiles and Decorative Arts*. New York: The Museum of Modern Art, 1972.

❀ ❀

COLOPHON

AFRICAN ART / VIRGINIA MUSEUM OF FINE ARTS

Produced by the Office of Publications of the Virginia Museum of Fine Arts, Richmond

Edited by Monica S. Rumsey

Graphic Design by Sarah Lavicka

Maps created in Adobe Illustrator by Lorenzo Walker

Photographic Research Assistance by Suzanne LeBlanc

Editorial Keyboarding by Best Secretarial Services, Inc., Richmond, Va.

Type is Garamond and Futura, set in QuarkXPress by Riddick Advertising Art, Richmond, Va.

Printed on acid-free Warren Lustro Enamel Dull by Carter Printing Co., Inc., Richmond, Va.

Smythe-sewn binding by Advantage Binding Inc., Baltimore, Md.

❀ ❀